ADVANCED STUDIO LIGHTING TECHNIQUES

FOR DIGITAL PORTRAIT PHOTOGRAPHERS

Norman Phillips

AMHERST MEDIA, INC. ■ BUFFALO, NY

All rights reserved.
Published by:
Amherst Media®
P.O. Box 586
Buffalo, N.Y. 14226
Fax: 716-874-4508
www.AmherstMedia.com

Publisher: Craig Alesse
Senior Editor/Production Manager: Michelle Perkins
Assistant Editor: Barbara A. Lynch-Johnt

ISBN: 1-58428-186-3
Library of Congress Control Number: 2005937368
Printed in Korea.
10 9 8 7 6 5 4 3 2 1

Contents

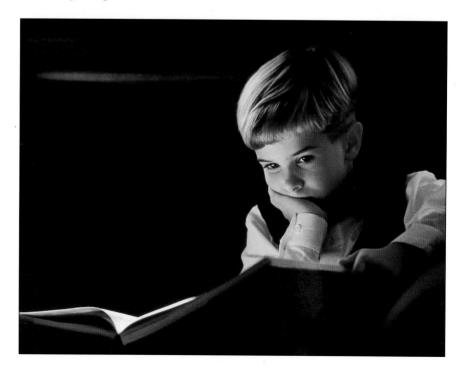

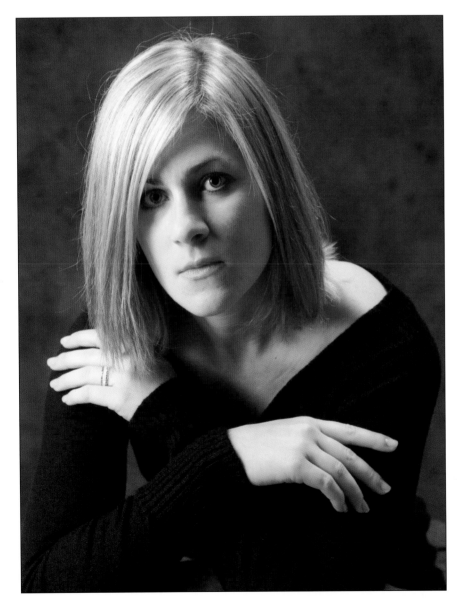

About the Author

Norman Phillips was born in London, England and became a U.S. resident in 1980. He is married, has three sons, and lives in Highland Park, Illinois. He frequently returns to London to visit family and provide seminars. The Norman Phillips of London Photography studio, located in Highland Park, Illinois, was established in 1983.

Throughout his career, Norman has been a judge at local, regional, and international print competitions and has presented almost 200 seminars and workshops in the United States and the United Kingdom. He is a frequent contributor to several magazines and newsletters, including *Rangefinder, Professional Image Maker, Master Photographer,* and *WPPI Monthly.* He has created eight instructional and educational video titles, instructional manuals, and is the author of *Lighting Techniques for High Key Portrait Photography, Lighting Techniques for Low Key Portrait Photography, Wedding and Portrait Photographers' Legal Handbook,* and *Professional Posing Techniques for Wedding and Portrait Photographers,* all from Amherst Media. Norman has created more than 240 images that have earned the coveted score of 80 or better, ten Best of Show ribbons, and many First Place Awards in various competitions.

Norman is the recipient of a wide range of honors for his photographic achievements.

Norman is also the recipient of a wide range of honors for his photographic achievements. He has been Registered as a Master Photographer by Britain's Master Photographers Association (AMPA), has a Fellowship with the Society of Wedding & Portrait Photographers (FSWPP), a Fellowship from the British Professional Photographers Association (FBPPA), and a Fellowship Degree from the Professional Photographers Association of Northern Illinois (FPPANI). He has also been awarded with a Technical Fellowship from the Chicagoland Professional Photographers Association (FCPPA), an Accolade of Photographic Mastery (APM) from the Wedding & Portrait Photographers International (WPPI), an Accolade of Out-

standing Photographic Achievement (AOPA) from WPPI, an Accolade of Exceptional Photographic Achievement (AEPA) from WPPI, an Accolade of Lifetime Photographic Excellence (ALPE), a Lifetime Achievement Award in Recognition of Service and Contribution to the Photographic Industry from SWPP/BPPA, and Recognition of Contribution to the Industry from WPPI. He is an honored member of the International Executive Guild. Four of his images were included in the World Council of Professional Photography Traveling Exhibit.

Acknowledgments

Producing the images and arranging them for a work of this nature is probably more complex than you might imagine. Models are always important, and without them much of this book would not have been possible. So thanks are due to a host of models who sat for me— Amy, Jean, Neil, Kerry, Kathleen, Duane, Larry, and of course twins Samantha and Heather, whose time in the studio while we delved into the lighting possibilities was invaluable to me. Thanks also to Melissa Carlson, whose modeling in the past produced so many truly exquisite images used for this book and previous books from archived files.

Models are always important, and without them this book would not have been possible.

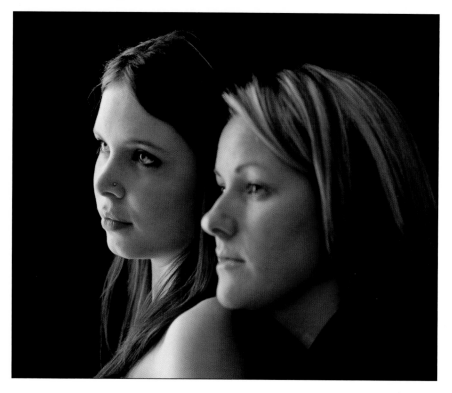

I am also grateful for the use of images of brides and grooms, which always prove to be of use as I continue to write. There is great value in the contracts that I use, which permit me to use images from those weddings in my books and for teaching purposes.

Special thanks also to the talented Kerry Firstenberger for her help with the digital files used to illustrate much of this book. Kerry has worked with me for eight years and is an emerging master of our craft.

Thanks also to F. J. Westcott for supplying me with their newest modifiers and lighting equipment.

Last but not least, thanks to my editors, Michelle and Barbara at Amherst Media. Authors get a lot of credit for their writing, but what readers mostly do not appreciate is the great work our editors do in checking our writing and especially arranging the images and diagrams so that the book makes sense.

I am also grateful for the use of images of brides and grooms, which always prove to be of use. . . .

Foreword

Having previously published two books on lighting, *Lighting Techniques for High Key Portrait Photography* and *Lighting Techniques for Low Key Portrait Photography* (both from Amherst Media), you might think there is little else for me to discuss when it comes to my favorite subject: lighting. But because light is the magic that enables us to create our images, we could, if time allowed, discuss the enormous potential it presents until the cows come home.

Light is all encompassing in the creation of images, whether they are photographic or the work of the painter. It is light that shapes everything we see and all that we may fantasize. Any one of us can create in our minds an endless array of images and crave the opportunity to put them on our preferred media. However, though the painter can take whatever time he needs to create his work, the photographer often has just one fleeting opportunity in which to capture an image. So having an understanding of light and how we may use it is a prerequisite in our craft.

In theory, with the aid of such digital imaging tools as Photoshop, we could return to any imprecisely captured images and reform the lighting pattern. But to do so with authority we would still need to understand lighting in all its possibilities. Therefore, rather than concern ourselves with digital tricks, we will learn how to record each image using innovative and creative techniques that ensure good lighting. Using light as our primary tool, we will learn how and when to defy the rules of traditional imaging in order to create impressions that stir emotions. The text and images in this book will inspire you to follow your senses and strive to reach a higher level in your photography.

Light and its effects on the world around us should continually fascinate us. I have always been intrigued by what light does as it shapes and illuminates the world around us, and I have ceaselessly studied it so that I may

Light and its effects on the world around us should continually fascinate us.

master its use. Not even the greatest of masters can claim to know everything about the primary tool we use in our everyday work. Even as I write this book I will be learning more about the subject than I am supposed to be as a master. By the time I have written the end of the book, I will be even more excited by what light will help me create, and I will be looking for every opportunity to produce even more exciting images.

I am inspired by the effects of light and hopefully, by this book's end, you will be too.

● A FINAL NOTE

You will find at the start of most chapters a list of terms that are important to our discussions. Also, beginning on page 123, you will find a description of the lighting equipment and accessories used in this book—as well as a few words on some other lights and modifiers that you might wish to use to produce your own creative lighting effects.

Not even the greatest of masters can claim to know everything about the primary tool we use in our work.

Introduction

● CONVENTIONAL PORTRAIT LIGHTING

Like most readers, I have pored over the pages and absorbed the text of many books on lighting. I have even written two books on the subject. But everything I have read and written centered on the lighting techniques needed to create portraits that our clients *expect* us to produce, regardless of the circumstances and environment. Even in chapters of my books where I have suggested a more creative approach, I have stayed within a zone that is commonly accepted as good portraiture, producing images based on the traditions we have established, which when followed, produce an image that is generally considered to be quite saleable.

As a print judge at many imaging conventions, I have been reviewing portrait and wedding images for a lifetime. Though the prints entered in competition are often beautiful and well done, they rarely depart from traditional styles. Perhaps there is a good reason for this phenomenon: the photographers who enter their work in competitions need the judges' approval to earn coveted accolades and degrees, and they know that print competition judges often reject innovative lighting strategies out of hand.

As portrait artists, we traditionally use basic three- or four-light setups—or window light—in our images. We create the relatively conventional loop or butterfly patterns on the subjects' faces. We illuminate the mask of the face by directing light onto the forehead, cheekbones, and chin. We produce the 3:1 or 4:1 lighting ratios that are traditionally regarded as acceptable. We control our lighting so that we do not burn out (or "blow out") the highlights, meaning that the skin tones lose detail, and we aim to provide detail in the shadows where appropriate. We also produce lighting that achieves an adequate separation between the subject and the background. We avoid creating hot areas on the subject that may be distracting, such as a hair light that draws attention away from the center of interest.

Yes, all of these criteria are important and require us to learn the critical lighting skills that produce acceptable portraiture. But, in meeting these standards and failing to produce work that challenges conventions, we do not create portraits with a more dramatic and emotional impact.

● A NEW APPROACH

In this book, I will show you how to use lighting strategies to create a truly artful portrait that departs from convention. I will demonstrate how we can use common lighting tools in a way that the creators of the tools probably never considered. We will modify common lighting patterns by either increasing or reducing the intensity of the light in order to create different impressions. Also, we will explore lighting styles that are rarely, if ever, used in professional portraiture. We are going to break the rules, and yet we will still produce images that are beautiful, fascinating, and absorbing. While I will discuss the basics of traditional lighting styles as a point from which to expand our creativity, the focus of this book will be: (1) to learn how to create images that challenge our viewers; (2) to show our subjects that there are alternatives to the traditional approach to portraiture; and (3) to produce portraits that are perceived to be works of art. We will use lighting styles to create portraits that present our subjects in ways that do much more than show how they normally look or that simply flatters them. We really *can* turn our portraits into fine art that is worth far more than traditional portraiture. Imagine the 30 x 40-inch portrait that you currently sell being worth double—or even three times—the price!

It is true that advocates of classic portraiture (yes, I have been amongst them) may suggest that some of the images we will strive to produce would fail the test of conventional print adjudication. However, it is important to remember this fact: as beautiful as many of the competition-caliber portraits may be, very few could be sold at a gallery exhibit. Producing evocative, one-of-a-kind images is our goal.

In reading this book, you will learn many lighting techniques that will allow you to produce images that can open up a completely new market for your business. At the end of this adventure you might want to expose your existing clientele to some new portrait ideas—something that will replace some of those odd pieces of art that they had framed simply to cover open wall space. Remember, you cannot sell what you do not show, so you might well use some of the techniques to demonstrate your ability to create wall décor of a different nature.

Reading this book and working through the ideas presented is intended to be something of an adventure. We are going to seek every opportunity to create something different, something emotionally uplifting. We will learn to see existing light—or the lack of it—and the unusual but flattering results it can achieve in a new way. We will learn to take advantage of creative lighting concepts not utilized before now.

> **INSPIRATION**
>
> Consider the work of great portraitists like Darton Drake, the Simones, Monte Zucker, and other prominent portrait artists, then go beyond the boundaries they have set. Open yourself up to the possibility of creating emotionally demanding work, and meet your own creative goals, from this point forward.

Traditional Lighting Styles

Portraits made using traditional lighting styles have their place. But in this chapter, we'll begin to use these portrait conventions as a creative and technical springboard to create something that does more than simply show how the client looks on a day-to-day basis.

Plate 1 shows a conventional head-and-shoulders portrait in high key. It was created according to an accepted formula for lighting portraits of female subjects, is pleasing to the eye, and satisfied the client.

The image shown in plate 2 resembles that shown in plate 1, but the angle of view was changed and there was a subsequent change in the subject's expression. In both portraits, there is a very gentle loop pattern on the subject's face, and the mood is delicate and light.

In plate 3, the goal was to create a different impression. The light was made much more specular to create a more dramatic, sculptured look that some viewers will find more appealing. The stronger shadows create an impression that says a little more about who the woman is. Compared to plates 1 and 2, plate 3 has more panache. Despite the differences among the portraits, however, all three fall into the traditional portrait category.

In plate 4, the specular highlights and the shadow were increased to create a darker, more somber mood in the portrait. This change proves the point that light, or a lack thereof, can have a great impact on the mood of a portrait and can move it into a different image category.

The lighting technique shown in plate 4 is rarely used, as most people would consider it too specular and out of context with conventional high key portraits. However, there is no doubt that this image, though it uses a conventional lighting pattern, is much more dramatic than the standard high key portrait. Gone is the loop lighting pattern; instead, a butterfly pattern is shown. Though this image is undoubtedly more dramatic than the earlier photos, we have barely touched on creative lighting techniques.

> **IMPORTANT TERM**
>
> Specular lighting. A specular light increases the contrast between highlight and shadow.

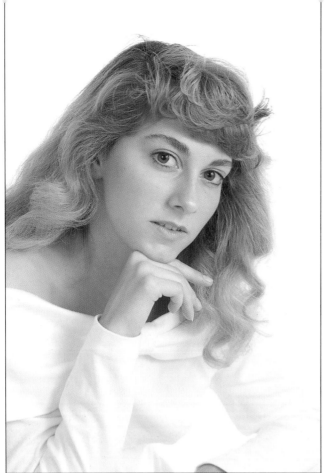

plate 1

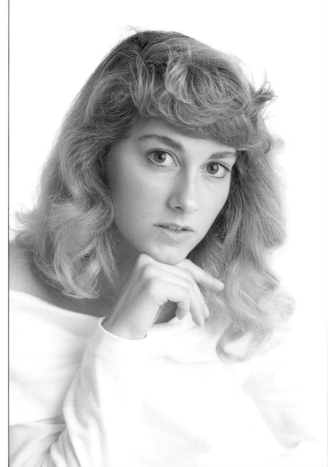

plate 2

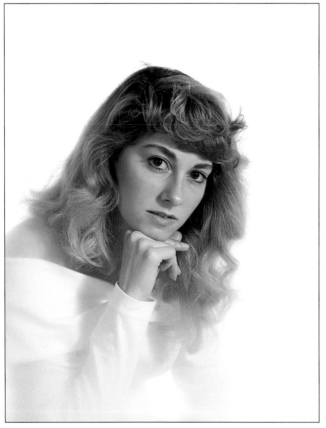

plate 3

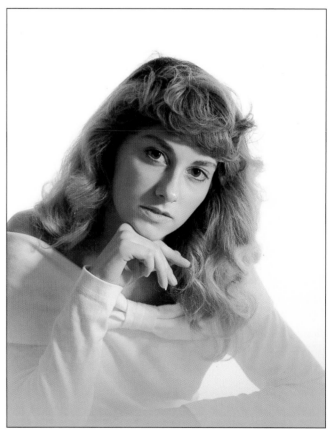

plate 4

The goal in producing the image in plate 5 was to change the mood to one of soft introspection. To accomplish this, the light was softened to achieve a more delicate and feminine yet absorbing rendition of the portrait shown in plate 4. Though plate 5 presents an example of a more creative lighting technique, the portrait still exhibits an excepted lighting pattern in which you can see the most delicate example of a butterfly pattern.

In plate 6, the subject's eyes are shown in a subdued lighting zone that requires you to look more deeply into the image. In this image, the subject is rendered in the same soft light, but because she was turned very slightly toward the camera, the lighting pattern also changed very slightly. Though it appears that the lighting ratio has changed too, it has in fact stayed the same. Note that despite the changes that were made to the lighting, the same butterfly pattern shown in plates 4 and 5 appears in plate 6.

Without truly pushing the envelope, I have shown some very simple examples of creative lighting. This is simply a demonstration to show that even while working within the accepted norm, we can be more creative with our lighting. It is but a beginning.

All of the images shown in this chapter are very saleable, but likely to a different client. Straying from conventional techniques—even slightly—may never earn print-judging merits, but it does not mean that you have produced a bad or unexciting image.

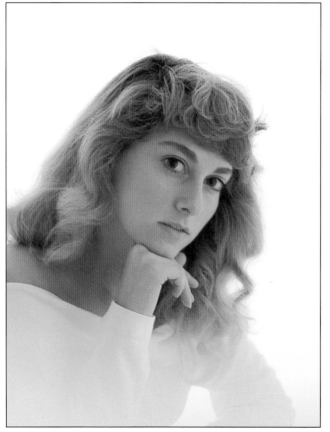

plate 5

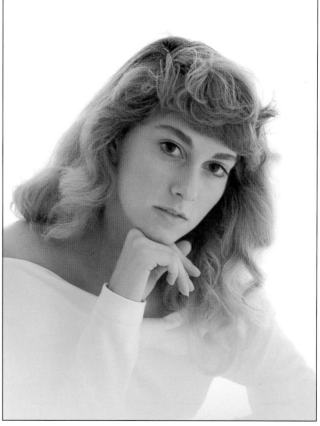

plate 6

2. Window Lighting

● **CLOSE-TO-THE-WINDOW LIGHTING TECHNIQUES**

Most portrait and wedding photographers are familiar with window lighting opportunities, but almost exclusively, the styles used fit traditional portrait lighting patterns. But window light can produce some incredibly exciting options, and some of those are described in this chapter.

In portraits made with window light, the subject is generally placed close to the window in order to take advantage of shorter exposures and smaller aperture settings. Almost exclusively my colleagues will seek to create the same lighting pattern at the window that they would use in their studio, as this is what is expected. But in producing this series of images of Melissa, I have sought to create portraits that are much more exciting. Let's investigate some of the opportunities that are available to us in order to create images of greater interest.

The Positive and Negative Sides of the Light. Portraits made in the positive side of the light source appear quite different than those that utilize the negative side of the light source. The positive side of the light is the most specular because it follows the most direct path of the sun's light. The negative side is opposite the positive side of the light, and the quality of the light that is produced is much softer, as no direct sunlight falls on the subject. See diagram 1.

When working with window light—or other natural sources of light—our subjects must be positioned where the light will produce the desired pattern, unlike in the studio where we are able to create light patterns by moving or modifying the artificial light(s).

To produce the image seen in plate 7, I placed Melissa at the positive side of the light to obtain a degree of specular light. My intent was to create an image that featured additional highlights and soft shadows that are normally not considered acceptable in traditional portraiture. I find these

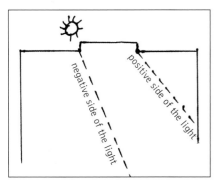

diagram 2

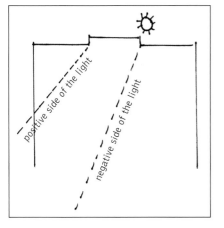

diagram 1

create a much more interesting rendering of the subject's face, and in this example, I particularly wanted to accentuate the subject's beautiful jawline to demonstrate its delightful femininity and to create a greater feeling of depth and shape. You can see the relatively intense specular light on Melissa's magnificent mane of hair at the right side of the image. However, instead of placing her in the traditional position at the window, I have moved her into the light path, but with her back to the light source. This allows the specular light to kiss her right cheek. In this pose, her hair was used to block the light to the other side of her face, which creates a beautiful, soft fill on the shadow side of the portrait. It also renders her nose, chin, and right cheek with delightful yet controlled highlights. This creates a little mystery in the eyes, especially her left eye—and a little sparkle.

In plate 8, I wanted to keep the delightful highlights that shaped Melissa's features in the previous image. However, this time, I asked her to raise her eyes to the camera to achieve a look that is no longer dreamy but provocative. Two completely different portraits were created without changing the subject's position or the lighting.

Proponents of traditional portraiture might critique that Melissa's hair is burned out, and this is true, but the charge is irrelevant because creating an effect that did not conform to classic portrait standards was the goal. In fact, the bright rendering of the subject's hair creates a glowing frame around the facial lighting pattern. See diagram 2.

In plate 9, I sought to create a profile image of the subject, using her hair as the backdrop. I wanted to ensure that Melissa's white top would reflect light up to her chin and create something of a hot rendering of her hair. To accomplish this, the subject was positioned a little farther toward the negative side of the light to allow a little specular light on the "deceptive" profile. (The profile position is "deceptive" because the actual head position is not a complete profile; rather, the subject's hair was used as a light block and as a result, you are unable to see her left eye.) This allowed me to render her right eye in a beautiful and enchanting view. Note how the light that reflects from the subject's white shirt also gently lights her jawline, which, with the light pattern on the mask of her face, creates a delicately sculptured facial pattern on the right side of her face. The lighting strategy creates a depth that traditional images fail to show. Had Melissa's hair not been used to block the light, the viewer would have been able to see her left eye, and it would have been a compromised profile.

For another and quite different impression, I sought to significantly increase the contrast between highlight and shadow to show a more challenging look in the subject's expression. In plate 10, you will see that Melissa was moved to the edge of the positive path of the light and closer to the window. She was turned almost to a three-quarter head pose. Using the light in this manner produced a dramatically rendered light pattern with a slightly greater than 4:1 lighting ratio. Note the gentle highlight on

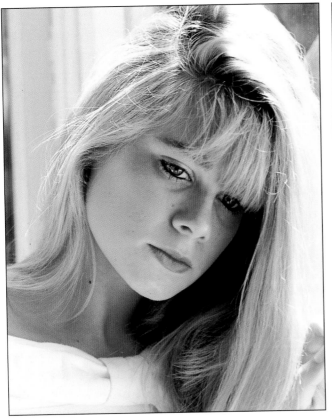

plate 7

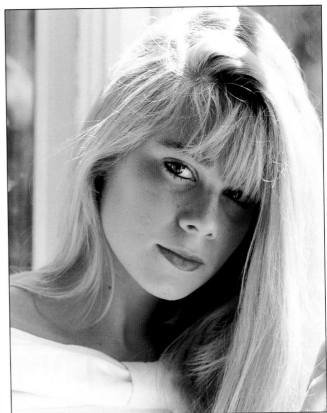

plate 8

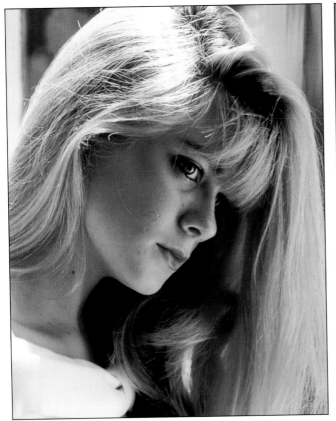

plate 9

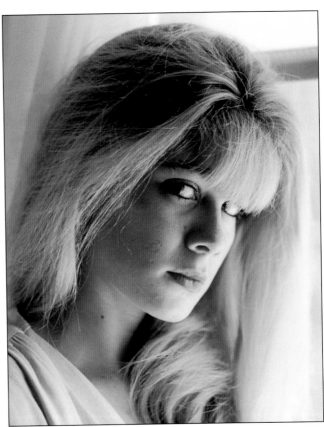

plate 10

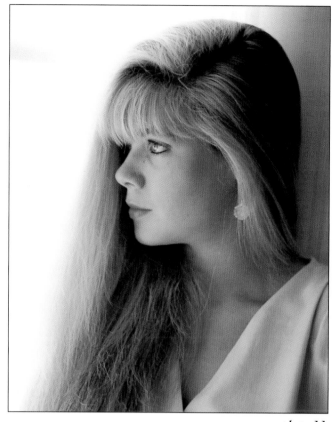

Melissa's right cheek that prevents the image from having a split lighting pattern. Additionally, because a more specular light was used to sculpt Melissa's face, her white shirt reflected enough light to gently outline her jawline, thereby creating additional depth to the portrait. The look in this image is much more striking than that shown in plates 7, 8, and 9.

In plate 11, my aim was to create a softer and subtler profile with gentle modeling and significantly less sunlight transmitted through the subject's hair. Melissa was posed in the positive side of the light, and in this profile image, her hair was once again used to block light from the bright window. Note how close the back of her head appears to the window frame. This position allowed the light to wrap around her facial contours, producing a delicate rendition of her face. Note too that she was positioned so that the long reach of the soft light created depth in the shape of her face. This portrait also uses a split key, as there are both high and low keys in the background, a photographic feature that is conventionally frowned upon.

plate 11

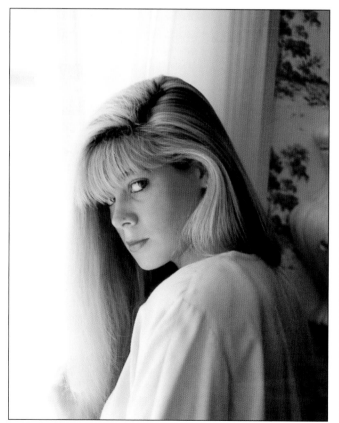

plate 12

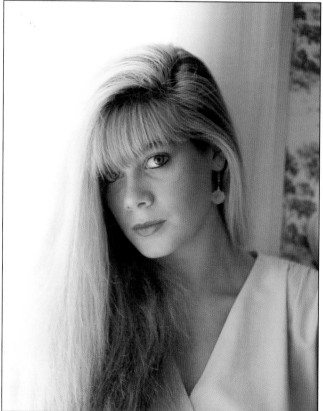

plate 13

In plate 12, in order to create a different light pattern that would more dynamically illuminate her face, the camera position was moved and Melissa was turned very slightly toward the light. With her head turned toward her left shoulder so that she could see the camera, the light very softly sculpted her face with gentle highlights. Because she was turned slightly away from the full profile view, plate 12 shows a quite different view of a very beautiful woman.

In this image, the light that produced a profile in plate 11 shaped her face very differently with delightful soft highlighting on the mask of her face. This pattern was possible because she was placed within the full path of the negative side of the light. If Melissa were placed all the way into the shadowed area, the full wraparound of the light would not have been maintained, and the ratio between the key lighting and shadow would have been virtually indiscernible.

In plate 13, I wanted to create what I refer to as the "kiss" lighting technique, in which just one or two elements of the subject's facial structure receives a little sparkle of light. This technique has been described in movie and video lighting as "dancing" lights, because when they are used in motion photography, the lighting creates a series of fascinating impressions that disappear quickly and leave viewers wanting to see more.

To accomplish this, without changing her relationship to the light, Melissa was turned slightly toward the camera to show a three-quarter facial view. When you look at plate 13, you can see the "kiss" on the tip of the subject's nose and upper lip and very slightly on her chin. (It is less obvious on her chin because her head was very slightly tipped forward so her chin fell slightly out of the path of the light.) In this image, the subject's expression is somewhat provocative. This is because her hair blocked the light and also created a much longer ratio between highlight and shadow, and her right eye is in deep shadow.

The series of images shown in this chapter demonstrate that when working with window light, creative approaches to lighting can produce delightfully different impressions that depart from accepted norms. Of course, each of the poses and lighting patterns could have been made to meet the requirements of traditional lighting styles with the use of additional lighting, such as reflectors or flash. You can decide for yourself which image style you like better.

● AWAY-FROM-THE-WINDOW LIGHTING TECHNIQUES

The great majority of portrait photographers are very reluctant to create images in light that is relatively flat or very soft, situations in which the lighting patterns are so delicate that they defy traditional lighting ideas.

To create the series of images shown in this chapter, Melissa, the model portrayed in chapter 2, was positioned 4–6 feet from the window. As a result, the light that is shown in the portraits is less intense and softer. It is

IMPORTANT TERMS

Back lighting. Light that is projected onto the back of the subject, producing a rim of light around the subject as he or she faces the camera.

Flared out. This refers to the effect that is achieved when a subject is overlit from behind, the edges of the subject are rendered bright white, and detail is lost in the glare. Also, any contrast that might be anticipated at the front of the subject begins to flatten out.

Flat lighting. Light that produces little or no ratio between highlight and shadow, resulting in a lack of modeling of the face. This can be produced using a pan reflector or with diffuse natural light.

Portrait lens. A lens that reduces compression between the front of the face and the ears. On a 35mm film camera, this is typically an 85mm lens, and on a medium format film camera, this would be a 150mm or slightly longer lens. Though your digital camera may accept a film camera lens, its effective focal length may differ. This is because the sensor size is slightly smaller than a full film frame in many cameras.

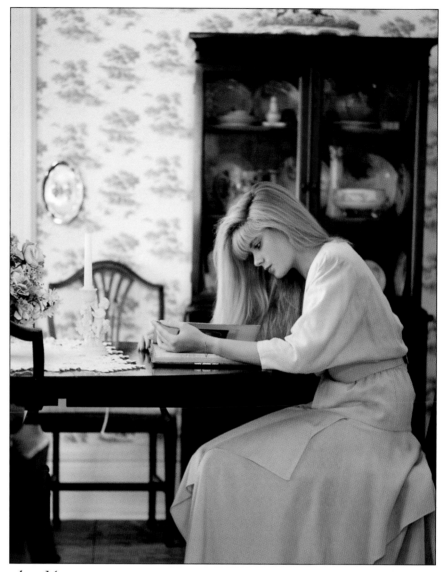

plate 14

Before setting up this portrait I reviewed the room and the various lighting options.

possible to create distinctly different portraits that are very appealing. Departing from the traditionally accepted lighting styles and creating images that are generally ignored by conventional portrait artists is a creative option because the style of portraits we can create are refreshingly innovative.

The portrait of Melissa shown in plate 14 was created in the family dining room. First and foremost, I wanted the portrait to present an environmental and fine art impression and to use light with a gentle wraparound quality. I also saw the potential to use the dark dresser as a backdrop for her white dress, while still employing some of the other features in the room.

Before setting up this portrait I reviewed the room and the various lighting options. The first consideration in creating any portrait is the light, the second is the background, and third is the composition. In this case Melissa was seated 5 feet from the window 45 degrees to her front and right. This

plate 15

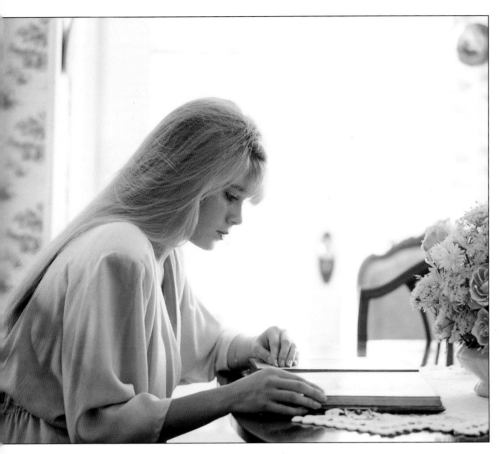

Back lighting can produce some delightfully delicate images. . . .

allowed me to photograph her against the dark furniture in the background. As a result, there is a contrast between the subject and the opposite tonal ranges shown in the background. The very soft and relatively weak light required a wider lens aperture or longer exposure, and in this case a wider aperture was chosen to reduce the depth of field.

Note the well-defined lighting pattern with delicate highlights on the mask of Melissa's face. Note too that with this lighting, Melissa's beautiful hair was perfectly rendered. The bright wall area between the window and the dresser created a split lighting of the background that would be regarded by traditionalists as a daring concept. The effect of the lighting over the total composition produced an image that goes beyond traditional portraiture and into the fine art image category.

This would be a difficult image to create with a softbox because the softbox would have to be exceptionally large and would prove to be virtually unmanageable in such a location. Had the room been larger and such a softbox used, it would not have produced the same overall illumination.

Back Lighting. Back lighting can produce some delightfully delicate images, and the position of the subject as she relates to the intensity of the light is important, or the shape of the portrait will be lost in the field of light. To create a portrait using a strong field of light behind the subject requires the photographer to recognize where the intensity of the light will fall off sufficiently that it will not cause the edge of a profile or other pose

to be flared out. When we find the correct position for our subject we can produce an excellent image that has the subject beautifully rendered against what is a high key background and also has delicate outlines that shape the profile.

In plate 15, Melissa was positioned in profile 5 feet from the light source, which produced a high key background. The quality of light was excellent, and the skin tones on the near side of the portrait, though beautifully soft, were rendered naturally. No additional light was used, yet the wraparound of the natural light produced nice facial sculpturing.

You will see that there is a little specular light around Melissa's nose, mouth, and chin. If we had moved her any closer to the window, the light would have been so intense that it would have destroyed the contour of her facial outline. Additionally, because of her carefully selected placement in the light field there is excellent depth within the image. The portrait also shows excellent detail in the subject's hair and dress.

The crucial factor with this style of lighting is recognizing where to place the subject and assessing how the overall exposure will render the entire composition. This requires that you recognize the ratio of highlight and shadow across the subject from the farthest point of focus and that nearest to the camera.

In plate 16, I set out to create a portrait with increased depth by having the light to my left fall onto the model's right cheek behind the frontal mask of her face and also the right side of her nose. The same light also renders her hair very nicely. At the same time I used light from the right to create the primary lighting pattern.

For this portrait Melissa was moved farther from the light source and was seated in a chair with a dark fabric. This allowed me to show her hair in relief against the darker background and create what would be called a split lighting effect except that the shadow side is primarily softly lit with good detail. This might be described as contradictory to the conventional lighting for a three-quarter view. This is because I have taken advantage of a second window light source to the camera's left that lights the right side of her face while the key light source from the window to our right sculpts her face. This two-light setup is mostly ignored or simply rejected because it does not fall within the accepted norm. One of the reasons for this rejection is that there is effectively no fill light. But it ignores a fundamental concept in terms of modeling a subject's face.

Between the two light sources there is an area of the mask of her face from her nose to the right cheek that is in shadow, creating a $3\frac{1}{2}:1$ ratio. This technique creates a depth and interest that a traditional lighting style fails to do. It also enhances the view of her pretty nose while at the same time keeps her eyes in soft shadow to create a little mystery.

The next phase in my portraiture of Melissa was to move from the almost three-dimensional impression to one in which she is shown in a

plate 16

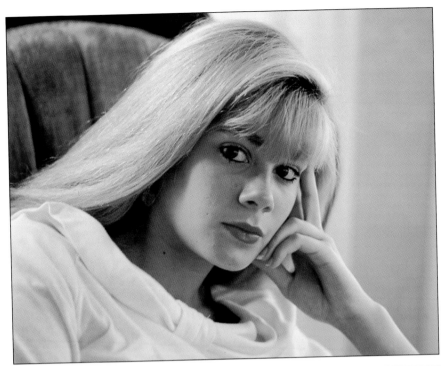

plate 17

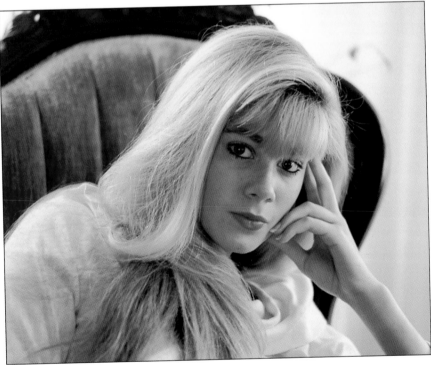

more dramatic lighting style—one that partially conforms to some of the accepted rules.

In plate 17, in order to create a different impression, Melissa's position remained unchanged, but her hair was brought to the front of her shoulder to create a soft, split lighting effect. The two light sources create a beautiful rim light around her head and hand that increase the feeling of feminine mystery, as we are able to see good detail in the shadow side of her face. This produces a portrait with several identifiable qualities that

often are considered separately, but rarely in one image. First, there is a very pronounced framing of Melissa's face using the light from both sides. This lighting frames a portrait that is soft, sensual, and intriguing with leading lines that run from her supporting arm and hand to bring you directly to the focal point of the portrait. The high-back chair creates a solid, low-key background that allows the subject's blond hair to be seen in relief.

Bridal Portraits. For plate 18, I wanted to create a slightly surreal silhouette of this bride so that the front and back of her gown would be rendered in a subtle outline. Again, the position of the bride in the field of light is critical in order to create this type of image. Had she been closer to the window, the light would have eroded the outline of her figure, and the

The position of the bride in the field of light is critical in order to create this type of image.

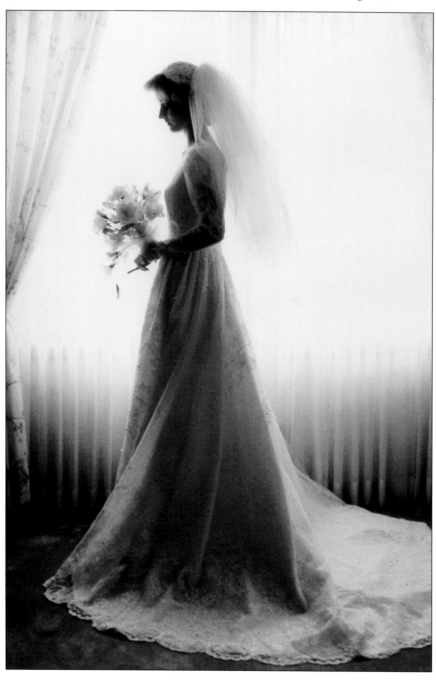

plate 18

plate 19

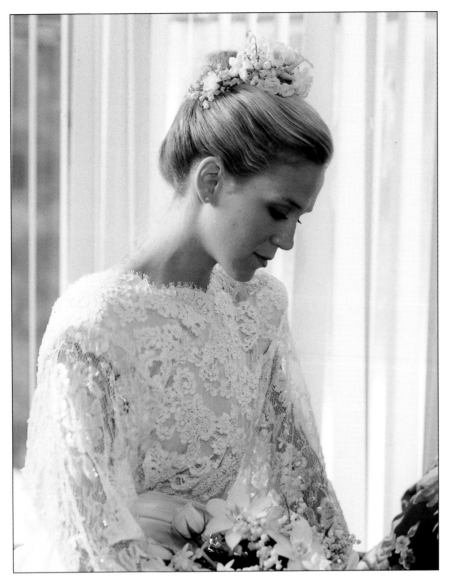

There are numerous creative options when working with natural light.

delicate rendering of her gown against the light would have been lost. If she had been placed farther from the window, then the outline would have been more solid, and the total figure would have been almost black with just a hint of the light transmitted through the delicate gown.

What is demonstrated here is that there are numerous creative options when working with natural light. With a little ingenuity and patience we can explore these possibilities and commit them to memory so that we may create almost any style of image that we can conjure up.

When creating the image for plate 19, I noticed this bride had a beautiful neck, the appearance of which was enhanced by having her hair up. I positioned her with her back to the main window light, with another window, which transmitted some 2 f-stops less light, to the subject's left. Note that with the subject in this pose, there is a line that runs from her shoulder up through her neck to her ear and which also accentuates her very pretty jawline in a lovely profile portrait.

The lighting style used was deliberately contrary to the conventional window light portrait. In a traditional portrait, we would have had her positioned facing the opposite direction so that the main light from the window would be projected onto her face as opposed to the back of her head. The unique setup allowed for the pensive mood of the bride to be enhanced by the light. Because this light had such a wraparound effect we see a nice gentle touch of light falling on the subject's right cheek that creates a feeling of shape and depth in what would otherwise be a very ordinary profile. Most important is that the overall effect is very feminine.

In plate 20, I used a technique that I cannot recall seeing in my review of other photographers' wedding images. The two subjects are presented in a relatively straightforward silhouette, but the viewer can see a little of the delight expressed by the groom. So often with the aim of producing a strong profiled silhouette we neglect to show the delightful expressions on the faces of our couples. To obtain this portrait I moved the camera a little to the left in order to see the light on his face. This is a subtle use of

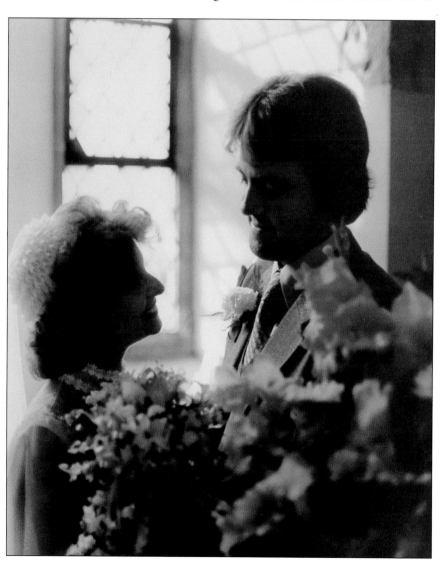

plate 20

plate 21

light by the alteration of the camera position rather than moving the subject. This would be difficult to achieve if you were using a tripod simply because the adjustment would be less than 6 inches and would need to be made very quickly.

Flat light is too often regarded as unsuitable for portraiture because we are unable to create the lighting pattern specified within the established rules. But flat light can produce some fascinating and beautiful images, because it draws the viewer into the eyes and mood of the portrait.

Plate 21 demonstrates the use of truly flat lighting, which results from retreating as far away from the light source as is practical. In this case a 1:1 lighting ratio created an absorbing rendition of the child's face as she was turned toward the light source, a window located behind the camera. When the light is this flat, the photographer can stand between the light source and the subject without blocking the light falling on the subject—provided he is using a portrait lens that allows him to work at least 4 feet from the subject. The exception to this would be if the room was very nar-

Flat light is too often regarded as unsuitable for portraiture. . . .

plate 22

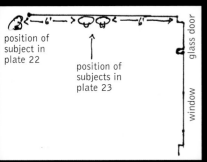

position of
subject in
plate 22

position of
subjects in
plate 23

window

glass door

diagram 3

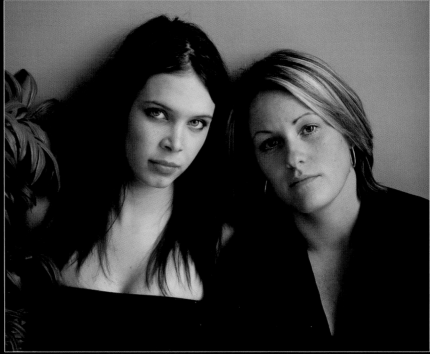

plate 23

row or the window was very small. In this case the window was an average size, so my being in the path of the light did not prevent the light from illuminating the child. This lighting technique causes the eyes to appear to follow you wherever you stand in the room.

Plate 22 is another example of truly flat lighting. This image shows how the lighting style opens the eyes in a way that traditional studio lighting does not. Moving the subject away from the window light until virtually all the specular light reflection in her eyes had disappeared created the impact in this image. The light at this distance from the window had a quality that rendered good skin tones. In this instance the subject was placed 12 feet from a very wide source of light. You could easily modify this impression by overexposing a little. This would eliminate most of the delicate skin texture and create a more glamorous impression. This is a technique similar to that used by commercial studio photographers to eliminate skin flaws and isolate the eyes from the other skin tones and texture.

In plate 23, the two young women, Jean and Amy, were positioned 6 feet from the same light source used in 22, but this time, the subjects were posed parallel to the direction of the light. The window was a very large light source which illuminated the women with a relatively broad light that primarily skimmed across their faces. This light is not as flat as that shown in plate 22, as we were 6 feet nearer to the window, but it still opened up the eyes of the subject who is slightly turned toward the light. At the same time it rendered the right-hand figure very differently. The subjects were deliberately posed in this manner in order to narrow the impression of the right-hand figure's face because she has a relatively wider facial plane than the other young woman.

When you review diagram 3 you will see that the women were placed so that the wide source of light was at its greatest intensity where they were seated, and the light at the farthest point from them was approximately 45 degrees away. This is why there is a slight fill on the shadow side.

In plate 24, I set out to capture an image of the happiness and vitality expressed by this bride. A much simpler lighting technique was used. The bride was posed at 180 degrees from the positive side of the light and facing the camera to create a striking image with above-average contrast, which is not modified by a fill light. A fill light, either flash or reflector, would have reduced the dramatic impact of the image. The bride's angle to the light source caused it to skim across her and accentuated the narrowing of her waistline. The strong shadows in the portrait enhance her figure and increase the impression of motion.

plate 24 (facing page)

The strong shadows in the portrait enhance her figure and increase the impression of motion.

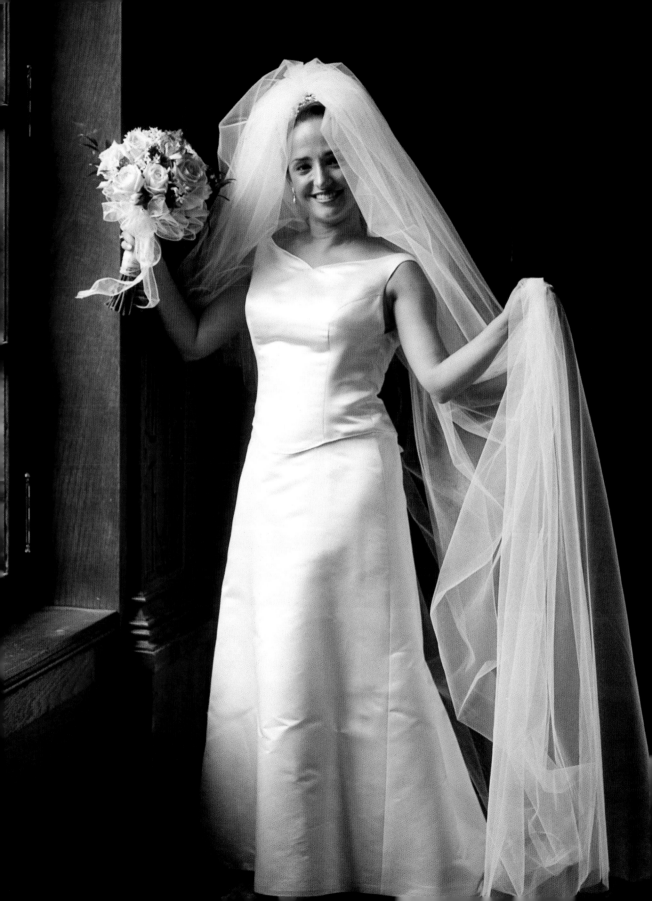

3. Recognizing Opportunities

Upon arriving at a location for a portrait and finding that the kind of light you would hope for is not available, don't shy away—instead, seize the opportunity to become creative! In plate 25, the most appropriate room in which to create this young boy's portrait had very weak light. The best composition for this portrait required me to use both the window and the urn and wall. The room was barely 10-feet wide at the window, so in order to use an appropriate lens it was necessary for the camera to be deeper in the room. This meant placing the boy with his back at the angle of the window and wall. Note the effect of the window light at his left side and how it creates form in his face and clothes. The illumination in the room required too long an exposure for such a young subject, so bounced flash was used to gently illuminate the front of the portrait in such a way as to not destroy the lighting pattern on his face. The exposure was ¹⁄₃₀ at f/5.6. If the bounced light had been even ½ stop greater, the beautiful soft tones would have been eliminated, and the impression would have been compromised, bringing it closer to a conventional lighting style.

The finished portrait retained the tones that were present in the room at the time of the exposure so that the environment that the family enjoyed was recognizable. See diagram 4.

Conventional window light portraiture often ignores the possibilities to create an image with greater depth and texture. The family shown in plate 26 was positioned at 180 degrees from the window. Their placement allowed me to achieve two objectives: first, to create a lighting pattern with added dimension, and second, to use the second and smaller window in the room as well as the window light in the room behind the family to create depth. The lighting on the subjects' faces has an unusual pattern that creates interest because it is distinctly different. Conventional portraits by

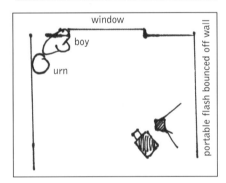

diagram 4 (above)
plate 25 (facing page)

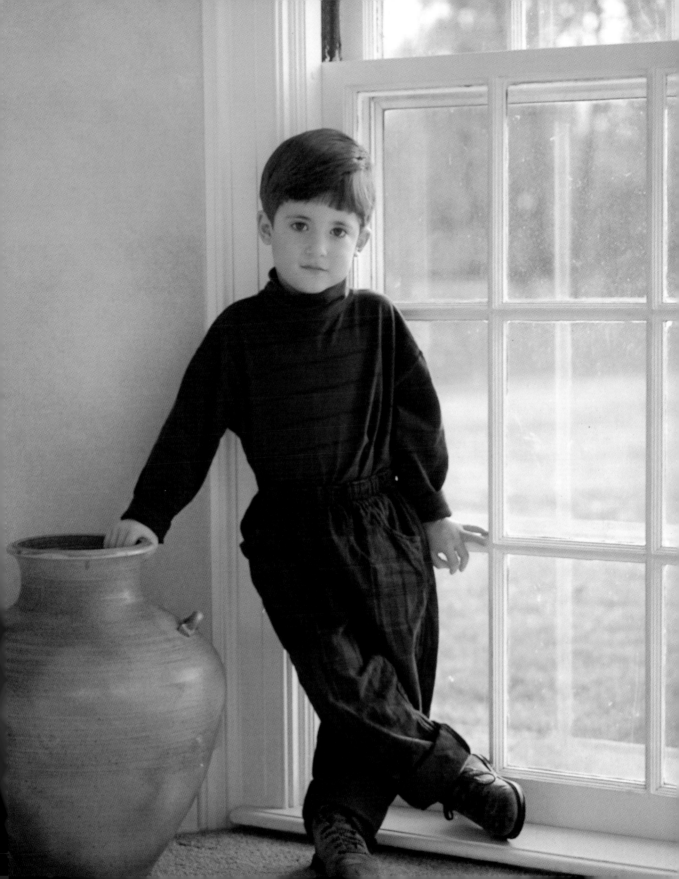

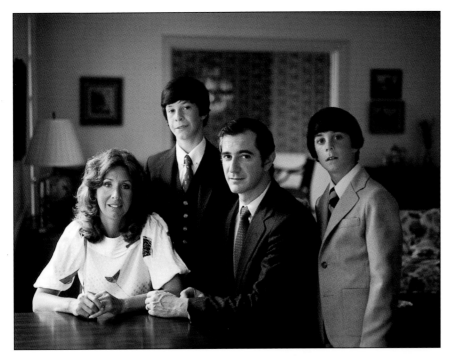

plate 26

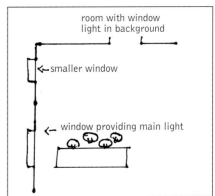

diagram 5

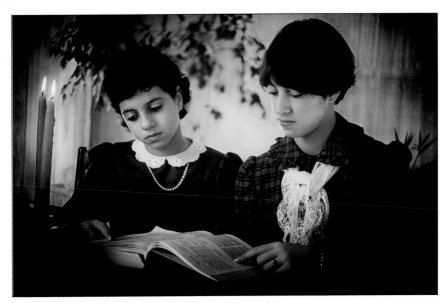

plate 27

diagram 6

window light would have been made using the window behind the family, and a fill light would almost certainly have been used.

By placing the group at 180 degrees to the window, the light skimmed across their faces very much like feathering the light from a studio softbox. Instead of the traditional lighting pattern on each individual being identical, each of the subjects has their own facial sculpturing, which I find very pleasing. In placing the family in this position a great deal more depth has been achieved by using the light from the second window to light the background. See diagram 5.

Creating an image of two by candlelight can prove to be challenging—unless you have a large number of candles and can achieve a reasonably convenient exposure. To produce the image shown in plate 27, the two young ladies were seated at a table reading a prayer book. Only two candles were used, so just a hint of their light fell on the subjects' faces. To create an impression that would represent how the candles illuminated the young women—and in particular the warm glow that the candles created—required metering the overall room light first, then separately metering the actual light from the candles. To obtain the desired effect, a flash tube was pushed as deep as possible into a white umbrella. This created the smallest possible light source, and the power of the light was dialed down to the minimum setting to provide f/4.5 at $\frac{1}{30}$ second. The length of the exposure ensured that the light transmitted through the white curtains behind the subjects created separation.

The umbrella was positioned 5 feet from the children and just to the left of the candles. This enabled me to record both the candlelight and the ambient room light at the same time. A curtained window in the background allowed very soft light into the room. To enhance the impression the image was slightly vignetted. See diagram 6.

Plate 28, a portrait of a child at a window, offers a different perspective on window lighting. Normally we seek to have a window that provides a light source that will fully illuminate at least our subject's head and shoul-

> A curtained window in the background allowed very soft light into the room.

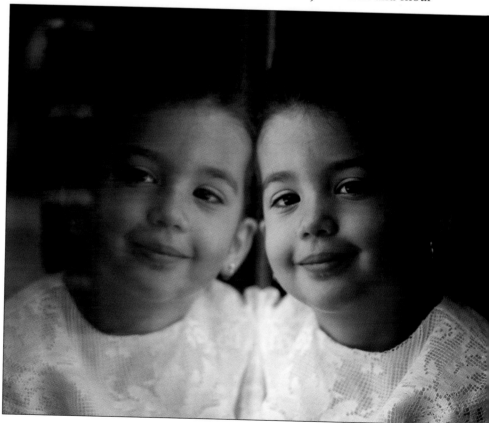

plate 28

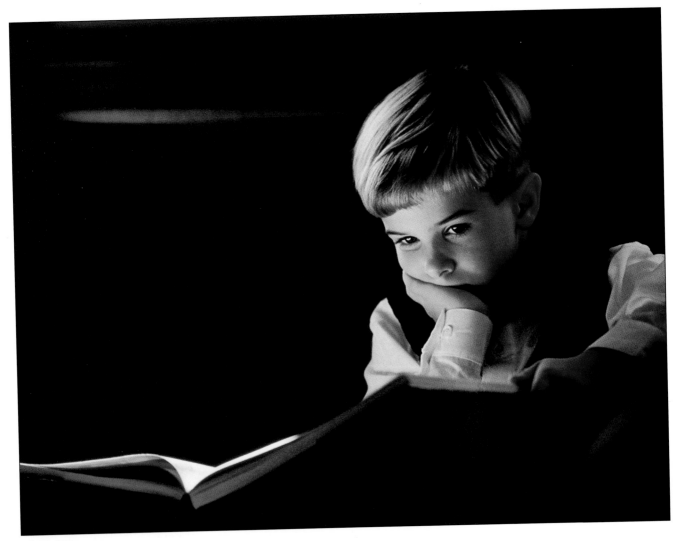

plate 29

ders. In this case the subject was positioned so that the dark background outside the window produced a mirror-like effect that enabled me to create a double image of the child.

The only way that we could have used a reflector as a fill would have been to place it below the child's shoulder level so that it would not be seen in the mirror. This would have caused the fill light to be directed up into the child's face. I prefer not to direct light upward into the face of my subjects as this often creates an unnatural rendering of the face.

This is a portrait that will always delight the child's parents, and I am always aware of this opportunity.

Sometimes the simplest of adjustments in the way we light a subject is all that is required to make the portrait special. In plate 29, a portrait of a boy reading by window light, the light from two separate windows was used. The key light was the window to the left of the camera, and a window to the right of the camera and behind the boy was used to separate the subject from the background. The white pages of the book provided the kicker light in this portrait and also created a leading line in the com-

position. In order to have this kicker, the book was tilted down and away to the boy's right to catch the window light. The window to the right produced some warmer light from the wall at the right of the camera. Important too was that I arranged for the portrait to be made at a time when the light from the window at the left would be at its brightest. Often, clothing and other items within our composition or elsewhere in the room can be manipulated and used as reflectors.

In plate 30, I wanted to capture the impression of devotion and commitment of a religious Jew holding a Torah. The holding of the Torah is considered a very sacred thing and is never treated lightly, so there is reverence by anyone who might be entrusted with holding it. So I sought to create an image with appropriate lighting, in this case a very soft window light.

It was important to have the Star of David on the Torah cover stand out strong together with the rich burgundy color of the material, yet at the

I wanted to capture the impression of devotion and commitment of a religious Jew holding a Torah.

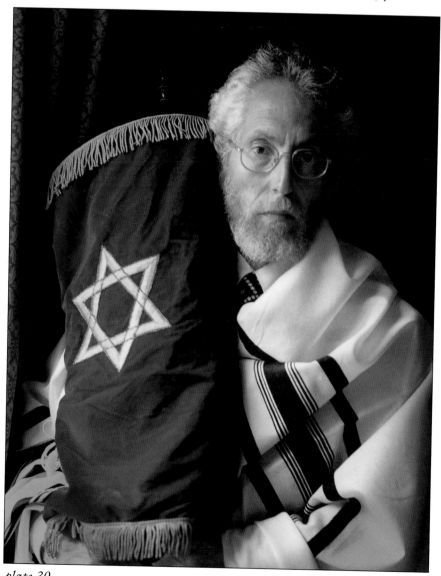

plate 30

same time have the subject depicted in a reverend pose and mood. To achieve this I had him turn slightly away from the window so that the left side of his face was rendered almost in shadow but with enough light for us to see his left eye and just enough for us to see his face in the shadows.

The effect of this low-key image is one of richness and has a look similar to that of a painting. Creating images with this Rembrandt-style lighting always creates the impression of something special.

Recognizing opportunities in natural light situations can open the door to creating images that are especially different and exciting. I conducted a session in a client's home, with the goal of photographing a new addition to the family. However, I found myself captivated by the baby's elder sibling, a four-year-old girl named Sabrina. This little girl had a special personality and dreamed of becoming an actress—a desire that showed in the way that she posed.

While photographing the baby I noticed Sabrina posing against a slightly yellow-toned wall in an area that would allow for a distinctive window lighting pattern that I felt would be exquisite for an image of the older child. The lighting shown in plate 31 came from a skylight and windows far to the left and was reflected by the light-colored walls, producing light that was soft and relatively even with a special glow that seemed well suited to Sabrina. I asked her to stand by the wall, and she immediately struck a dreamy pose. The very even light allowed me to capture her eyes as if they were pools of water with just a hint of a catchlight from the light above. When you look into those eyes you can see she is in a different world. Any other style of lighting would not have rendered the same mood of dream and fantasy. This image is one of my all-time favorites, yet no judging panel has been able to appreciate it as much as I do.

When viewing wedding albums and wedding prints entered into competition, it is apparent that photographers rarely use light that emanates from angles considered nonstandard by proponents of traditional portraiture. As someone who always seeks out unique lighting opportunities, I recognized the opportunity to use the available light shown in plate 32. In this image, my subjects were posed on a landing of a stairwell with the only light available from a window situated well above and to the camera's left. This light was so soft it produced an almost magical, delicate, and romantic lighting pattern. The fact that there was no additional fill light used to illuminate the right side of the portrait added to its overall beauty. The light presented the bride's pretty nose and lovely face exquisitely and created a more rugged lighting pattern on the groom's face, because he was lit from the "wrong" side. To add fill light to the front or light to the right side of the portrait would have totally destroyed the beauty of the image.

I am always looking for this special light, and so we will return to this technique in chapter 4.

plate 31 (facing page)

The very even light allowed me to capture her eyes as if they were pools of water. . . .

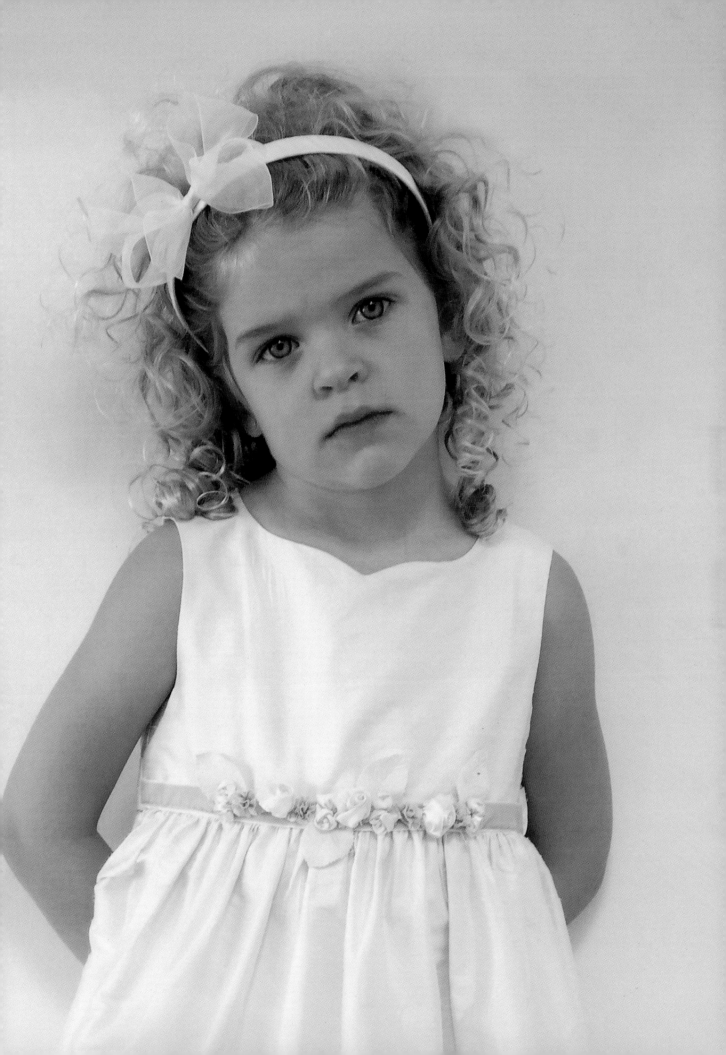

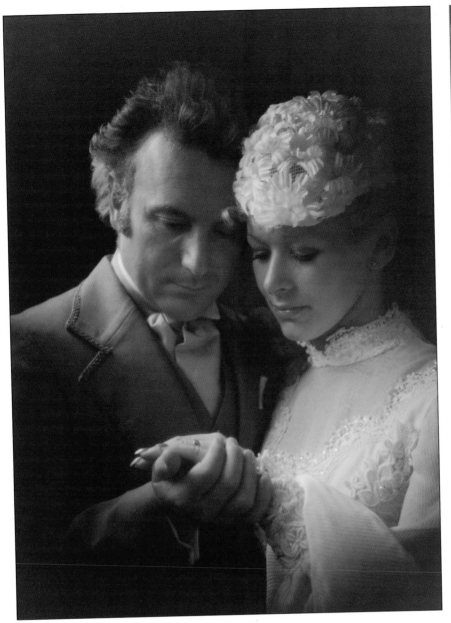

I appreciate that beauty is in the eye of the beholder, and what is beautiful to some may not be to others (I recall an African chief referring to a beautiful blond whom most Western men would die to date as ugly), but the lighting strategies shown in this book will cover a wide range of tastes. While some of the effects may not be your cup of tea, you may well pick up on some of these possibilities at some time in your career.

plate 32

When working at a wedding I have frequently sought the opportunity to capture images by candlelight as I feel they have a special romantic appeal. Too often, however, the circumstances do not allow me to get what I would like; however, when the circumstances permit, I never miss the opportunity.

Pure candlelight rarely produces sufficient illumination to allow us to create an image other than with a long exposure, and in most cases we will need a tripod. For most situations a tripod may be a cumbersome tool and slows the photographer down, which sometimes will mean missing a precious moment. In plate 33, a low power setting on a diffused flash allowed for a handheld exposure of $\frac{1}{30}$ second at f/2.8. The flash was diffused by an opaque cone, and the flash was tilted upward so that only the edge of the light was directed at the subjects.

The wide-open lens allowed me to capture the candles very brightly in the foreground of the composition, and with the controlled flash the couple are rendered in that special, romantic soft light.

Rim lighting can be very appealing and can be used to create dramatic and romantic images; it is something that I have a special yen for. In plate 34, a light was placed low and behind the bride and groom to create the

plate 33

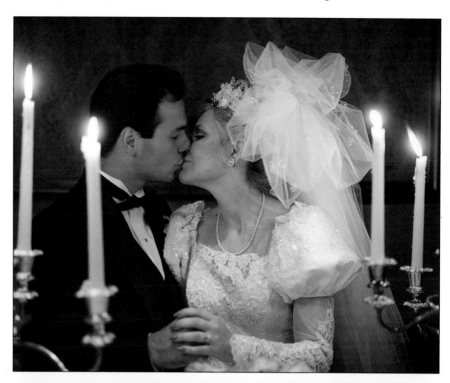

plate 34

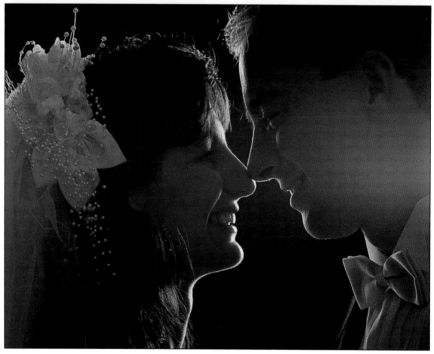

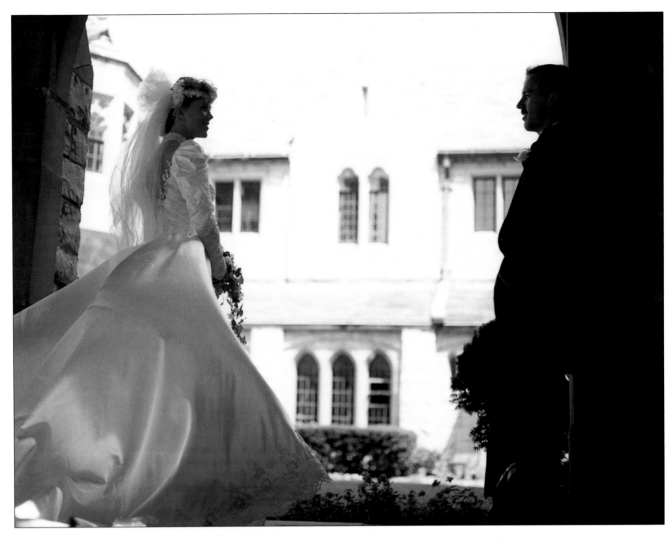

plate 35

rim of light that follows the contours of their faces. It is important that the camera cannot "see" the light, or it will create flare, and the shape of the image would be lost. The exposure is calculated to match the power of the flash and will very slightly illuminate the camera side of the image so that it is not a total silhouette.

In plate 35, an opportunity to create a subtle silhouette was irresistible. Observing the sunlit building behind an arch would provide a high key background with enough reflected light to create a soft image of both the bride and groom. The light was sufficiently strong that it also created a beautiful impression of her gown, which showcased its beauty. We can never show the beauty of a bride's gown too greatly as the gown is one of the most expensive purchases the bride makes for her wedding day.

The overall impression is romantic and always a popular image style for the newlyweds.

In plate 36, we demonstrate another form of back lighting using the bright light illuminating the area beyond the arched wall, which is coming from the right of the bride and groom. In order to capture this image the couple was positioned a little to the left of center to avoid too much light

falling on the groom's face and additionally washing out the bride's gown. It was also important to have her in the good light, as always should be the case, so she is at our left. The exposure was calculated so as not to overlight the camera side of the image, which would have brought the portrait into a totally different impression. The exposure was also calculated to record the greenery in the background as a backdrop.

The relatively specular light on the bride's veil also created a softbox-like illumination that assisted in rendering her gown in detail in the image.

plate 36

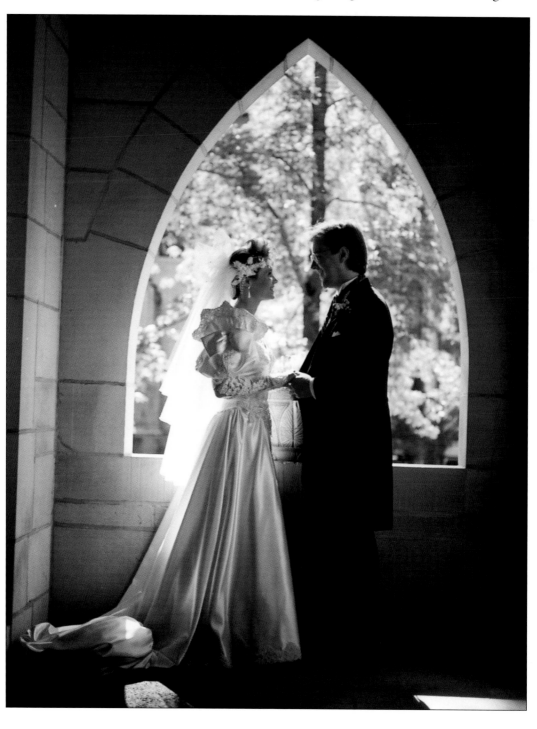

4. A Single Light Source

In plate 32 (previous chapter), we reviewed an image that was created with light from high above the subjects. In this chapter we will discuss the techniques that can be used in the camera room to create fine art style images with a real sense of mood that set themselves apart from any we might expect to see in a portrait portfolio. These portraits are so individual and personal that they are of a greater value to our clients than conventional-style studio portraits yet are still appropriate for our portrait clients looking for something unique.

In plate 37 (page 46), Kathleen is presented in a pose looking down. The light was carefully directed to just kiss her hair and her nose, with just a hint of light falling on her left cheek. Also, there is a little reflected light on her forehead and chin. The light used was a double-scrimmed 24 x 28-inch F. J. Westcott softbox placed behind a subtractive screen and tilted so that just the small corner directed light onto her head. The subtractive screen is white on one side and black on the other. In this case the white side of a screen was placed to the subject's left to block the light, and the black side of a screen was positioned on the subject's right to prevent any reflected light from falling on her. The setup allowed enough light to gently catch the highlighted areas and keep the rest of the image subdued as her hair at her right prevented light from falling on her right cheek. Note how her hair created a soft outline around her face. See diagrams 7 and 8.

Some time ago Michael Freedman, while lecturing across the United States, asked his attendees, "What's wrong with this picture?" He argued that, because the subject in the picture was not looking at the camera, the portrait was not as saleable as it would be if the subject were doing so. This portrait of Kathleen has a quality that goes beyond "looking" at the camera. It defies tradition, is intriguing, and demands our attention. There is a special "feel" to the image that is due to the fact that we are unable to see

These portraits are so individual and personal that they are of a greater value to our clients. . . .

her face as we would in a conventional portrait. She and her family will know that she is the subject of the portrait, and the image would make excellent décor for the wall in her home. There is a distinctive mood to the portrait, artsy yet very personal.

In plate 38, Kathleen slightly raised her head allowing the viewer to see her eyes. This slight change in her pose allowed a little light to illuminate her eyes and a little more specular light to fall on her left cheek. Suddenly, with just this very subtle change, a more intriguing image was produced. Note that the soft outline created around her face in plate 37 is retained in this image. The eyes now have a little mystery, and there is an impression of a challenge or question in the subject's expression that is enhanced by the lighting pattern.

As we work, any adjustments or modifications to our lighting should be directed toward creating the desired impression. With our knowledge of these lighting techniques we can create an array of different impressions at the same session. Each can be made to have our subjects communicate different moods and attitudes.

Another little change created the image shown in plate 39. Kathleen raised her head to look directly at the camera and, without moving or changing the lighting setup, we produced a completely different image with one eye hidden in shadow and the other appearing to question the camera's purpose. Because the right eye is presented in shadow, her left eye appears to be much more direct and purposeful. Our lighting can create the desired mood and expression when tightly controlled and carried out with a particular result in mind.

To produce the effect shown in plate 40, the model once again changed her head angle to create something akin to a traditional portrait, yet the image is much more attractive than one produced using the normal strict lighting pattern because the lighting technique used was very different from any of the recognized styles. Even the somewhat heavy shadow below her nose is not as offensive as it would be in a traditional portrait lighting setup. To quote David Ziser, "The difference is the difference," something that I have remembered since I first heard him say it. And being different is what this book is about.

This innovative lighting technique creates much greater interest than that found in a traditional portrait.

Plate 41 shows the model turned very slightly away from the camera but not so far as to allow the light source to light her right eye as her left, yet there is a catchlight in the shadowed eye, which draws the viewer into the portrait, something I advocate in order to make the work stand out.

There is a little resemblance to the traditional lighting pattern in this image as the mask of the subject's face is illuminated similarly to the conventional manner and there is a distinct 5:1 lighting ratio. The key difference is that a strong contrast style was employed—one that is more de-

. . . we can create an array of different impressions at the same session.

manding than would be produced in the 3:1 or 3½:1 ratio—and her right eye is hidden in shadow. The impression is one with a little mystique because the shadowed eye causes us to seek it out while at the same time her left eye has a beautiful soft, seductive impression.

This sequence of five images illustrates that innovative lighting techniques can produce portraits that are not just different but unique and absorbing. The style of the portraiture prompts you to look longer and more deeply into the images than do conventional photos, which simply present the subject in a straightforward way. Most fine art buyers are drawn to art pieces because they provide them with a greater source of interest. This is the reason why they are typically displayed in such homes.

plate 37

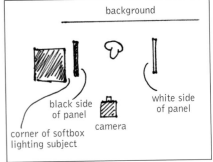

diagram 7

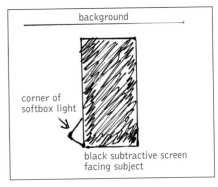

diagram 8

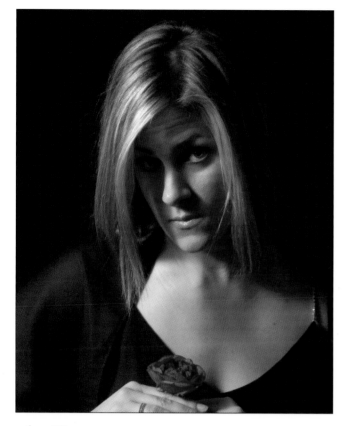

plate 38

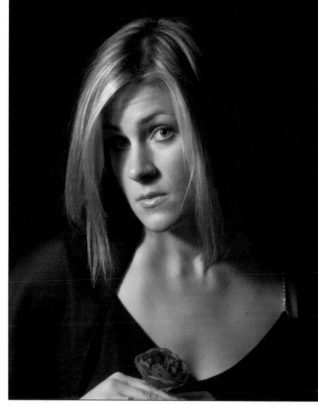

plate 39

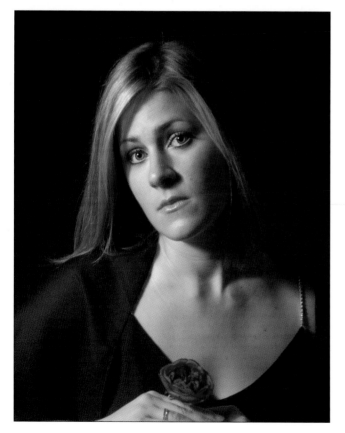

plate 40

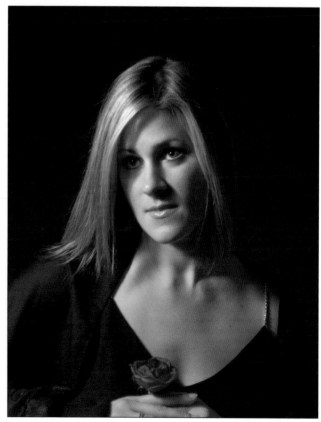

plate 41

5. A Second Light Source

The only light source used to produce the images shown in plates 37–41 (previous chapter) was a modified softbox. To produce the images shown in this chapter, a second light—a hair light—was added. However, as you will see, this light serves as more than a hair light.

There are a number of ways that we can light our subjects' hair, by directing a selection of lighting tools onto the hair from the side, the back, or from above. To achieve the results shown in the images in this chapter, the light, an F. J. Westcott Stripbank with a front diffusing screen, was directed from above. As shown in the portraits shown in plates 37 through 41 (previous chapter), adding this form of light softened the overall lighting pattern, creating a warming and rounding effect on the model.

In plate 42, the added light source created a more distinct rendering of the subject's hair and brought her left shoulder out of the shadows, which in effect made the image softer overall and created greater depth. At the same time the original light pattern was undisturbed except that her left cheek had a little more illumination. This also illuminated her hands, making them a significant element within the composition. The fact that her left shoulder appears a little hot is not distracting but helps to create a little extra vitality to the portrait. This means that we can purposely introduce a brighter element into the composition in order to create interest, so long as it is controlled.

Despite this modification the portrait is still very different from what we are accustomed to seeing. It has a more artful look to it, which will appeal to those wishing for something uniquely different from the traditional head-and-shoulders portrait. There is greater depth and an appearance of an additional dimension.

In plate 43, we continue to explore ways to change the mood and use light to enhance expression. While this portrait was made using the same

There are a number of ways that we can light our subjects' hair. . . .

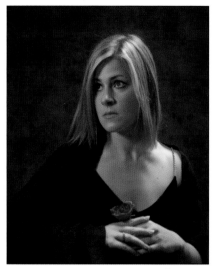

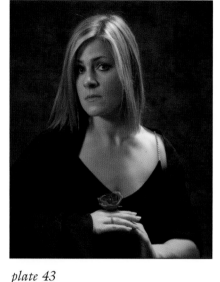

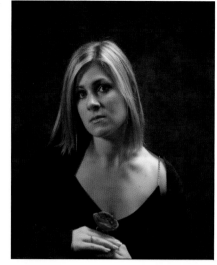

plate 42

plate 43

plate 44

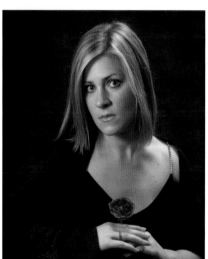

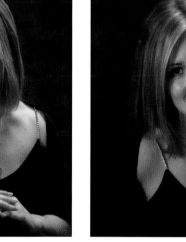

plate 45

plate 46

lighting setup used in plate 42, the model directed her eyes toward the camera with a wistful expression, which was enhanced by the lighting. Compare this to the more pensive mood created previously. Had we used conventional lighting setups, the two impressions shown here would not have been as effective or absorbing.

In the conventional sense, the tight loop around the subjects' nose in plates 42 and 43 increases the impact and interest. In each of these portraits I have sought to create the impression that the subject is communicating with the viewer.

In portraiture, a primary issue is the way that skin tones are rendered. Conventionally, we seek to represent the subjects' skin tones in the most flattering manner possible, and in doing so we tend not to create dramatic mood and expression in our portraits. Whether to light for drama or to produce a more traditionally flattering image is a judgment call; it is about

the philosophy we employ as artists. Are we following the trends upheld by our predecessors and peers, or are we seeking to be uniquely individual in our work? Remember that we have a choice: to conform to the mold or to break from tradition.

Kathleen was asked to slightly raise her head to produce the image shown in plate 44, and as a result, she appears almost as if she were looking down her nose at us. We were able to produce an effect that more graphically rendered and sculpted her features by gently lighting her forehead, the tip of her nose, and her left cheekbone. This adds significantly more depth to the image, and her beauty is much better represented. At the same time her eyes have a more demanding appeal. The way we use light to sculpt our subjects differentiates our work from that produced by our colleagues.

In plate 45, Kathleen was positioned in a more traditional head pose simply to demonstrate that this creative lighting works equally well in this style of lighting and pose as when we are seeking to create fine art portraits. The lighting produced an image that has an almost Renaissance look to it and appears less photographic. The skin tones have the quality of a painting as opposed to a photograph. The aim here was to produce an image with a quality that a discerning client would want to display instead of shopping for a framed art piece that has no personal relevance.

In plate 46, Kathleen's head was tilted so that the light from above created a lighting pattern that is virtually opposite to the conventional three-light setup. Instead of lighting the mask of the face and allowing the rest of her face to fall into a recommended ratio, the mask is in shadow, and where we would expect there to be shadow we have light. This defies the norm, yet we could argue that the resulting portrait is no less endearing. If you were in a restaurant in subdued light coming mostly from above you might well have this same lighting impression, even if not as precisely controlled, but you would find this woman no less attractive and alluring. The issue is that we have been trained to accept a conventional approach, and we are discouraged from doing anything different.

If this print were entered into competition, the judges would deduct points because the little glare on Kathleen's nose and right cheek were not toned down. Toning down the glare would reduce the portrait to something near to the accepted norm, but I prefer it as it is. I feel that this "flaw" makes the portrait more interesting and shows potential clients that the work I produce is different from that created by my peers.

An innovative F. J. Westcott lighting modifier developed by Ken Cook was used to create the image shown in plate 47. The modifier, called the Master's Brush, vignettes the light from the original light source, allowing the photographer to focus the light precisely where it is required. Kathleen was positioned laying down so that we could fan out her beautiful hair. The Master's Brush was positioned 30 inches above and slightly to my left to

Remember that we have a choice: to conform to the mold or to break from tradition.

plate 47

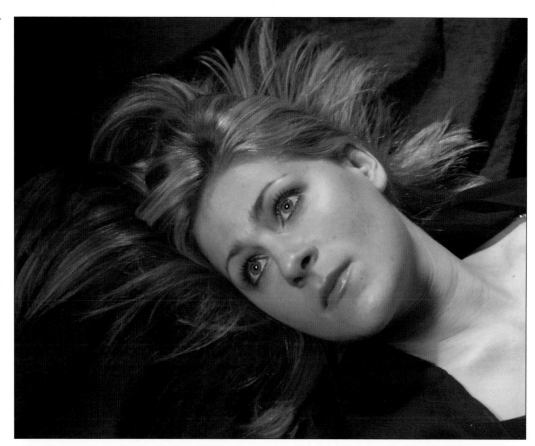

plate 48

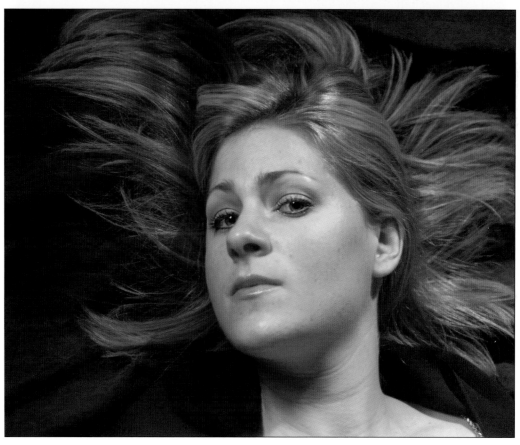

plate 49

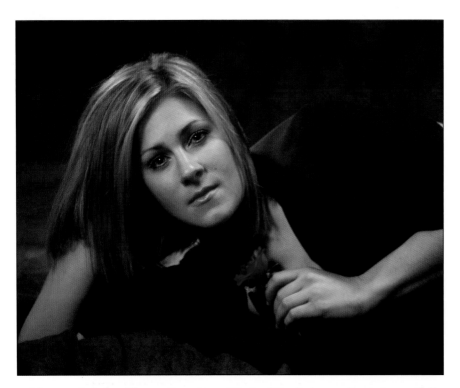

achieve a slightly oblique direction of light. The light quality is beautifully soft and creates a very pleasant skin tone. The control the Master's Brush offers means that there is much less need to manipulate a modifier such as a softbox to precisely focus the light.

Note the beautiful lighting of Kathleen's eyes and the roundness of the modeling of her face. The built-in vignette in the modifier allows us to focus on her face while subtly vignetting her hair. This quality is shown to a greater degree in plate 48, where the model is presented with her face turned slightly away from the camera, which resulted in more sensual skin tones. Note the softness in the shadow area on her neck in both images and how her hair is nicely illuminated and helps to create a very delicate and feminine impression.

In plate 49, Kathleen laid on her elbow, which caused her hair to fall away from her face, opening up the full width of her facial structure. The Master's Brush was used once more and a hair light was added just behind the plane of her head as it relates to the camera to create a little additional highlighting on the mask of her face and to more vividly show her blond hair. The same lighting pattern is retained as was used in the previous images, but the addition of a second light produced a little more vibrancy.

Note that the built-in vignette in the Master's Brush reduced the illumination outside the facial coverage so there was no need to use a vignette on the camera or to create one digitally post capture.

The subtleties of these lighting and posing variations demonstrate that there are endless ways for us to create portraits of great interest while using the minimum of lighting equipment.

Note the beautiful lighting of Kathleen's eyes and the roundness of the modeling of her face.

6. Eyes without Catchlights

Lighting our subjects' eyes has always been one of the key elements in our portraiture because when the eyes are not properly lit the portrait fails to show the subject in a totally recognizable and vibrant way. Generally, we expect to see catchlights in the eyes at approximately 11 o'clock or 3 o'clock, depending on which side the key light is placed. Sometimes there are two catchlights in each eye, a feature that causes the eyes to appear as if the subject is staring. Oftentimes this flaw is removed using one of the various artwork techniques.

Portraits that have catchlights in the eyes have a certain sparkle, yet portraits created without catchlights in the eyes are likely to be much more enchanting and draw us into the depths of the subject's thoughts and mood. Another interesting aspect is that when there is no catchlight in the eyes and the subject is looking directly forward, there is the impression that the eyes are following you wherever you are in the room where the portrait hangs. This is because without a catchlight the eye is focused to the point the photographer had the subject direct their attention. Without the catchlight the eyes could be following you anywhere you roam.

In order to create a portrait without catchlights we need a very large source of light as it relates to our subject. Remember, the larger the light source as it relates to the subject, the softer the light will be, regardless of what kind of light it is.

The light also needs to have a very even coverage, so the light cannot be one that has a center-weighted light source such as the most common softboxes, a very large pan reflector, or even an umbrella that is placed more than the distance of its circumference from the subject.

In plate 50, the desired effect was achieved by using an F. J. Westcott Spiderlite, placed close to the model. The Spiderlite is made up of a series of individual daylight-balanced fluorescent or incandescent lamps, which

plate 50

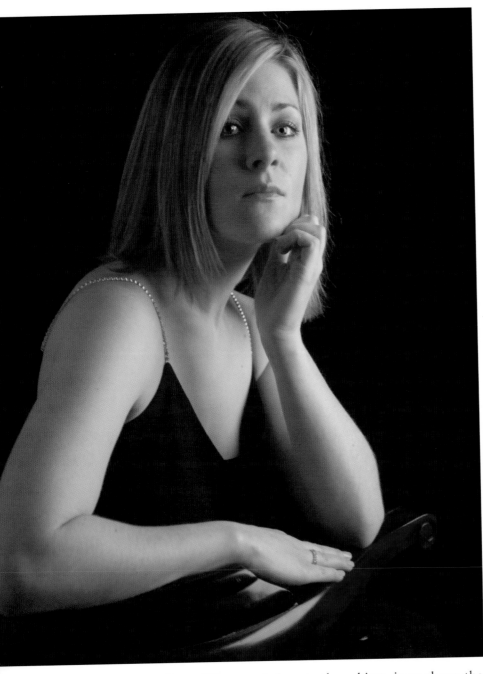

Kathleen is at the edge of the light as if she were positioned at the side of a window.

are placed in a softbox. When used close to the subject, it produces the most beautifully even type of lighting coverage.

In this image, Kathleen is at the edge of the light as if she were positioned at the side of a window. Her eyes, though mirroring the light, are catchlight free. They are rendered as if they were undisturbed pools of water. Note too how precisely her features are rendered with what might traditionally be described as a very tight loop around her nose. The angle of her head to the light produces a conventional lighting pattern, but the quality of the light this close to the light position is exceptional as it renders beautiful skin tones. This almost flat lighting reduces any skin blemishes, as would other flat lighting modifiers such as a pan reflector. The

Spiderlite is an innovative lighting tool that allows us to be creative in the studio instead of at a window on location.

To produce the image shown in plate 51, the same light source was used, but this time, the model was turned away from the softbox and was positioned at a different angle to the light. This allowed us to create a more distinct lighting pattern, yet the light was still very even so the skin tones in the portrait are excellently rendered. However, you will note that while the left eye still holds the reflection of the light without a distinct catchlight, her right eye was rendered differently. There is a reflection of the light, a catchlight, and a hot light in the white of her eye. Whenever we have a subject at too oblique an angle to the light we run the risk of a hot

The light was still very even so the skin tones in the portrait are excellently rendered. . . .

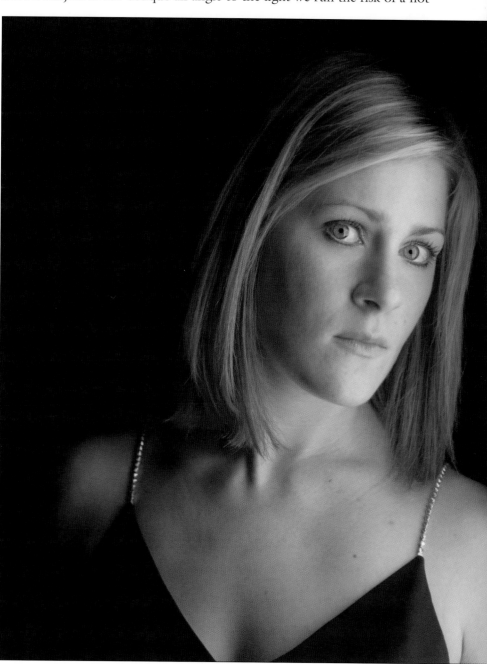

plate 51

plate 52

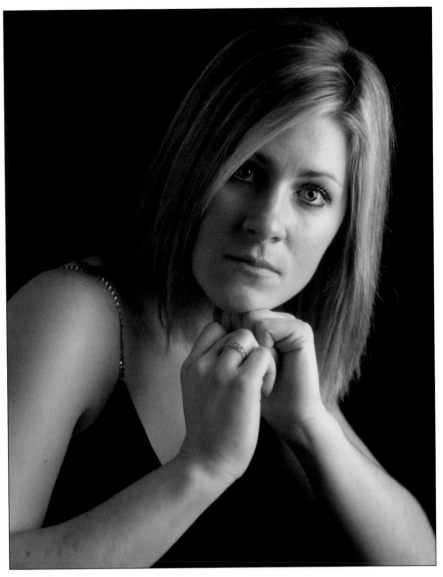

The light literally wraps around her figure and arms as if it were caressing her skin. . . .

light reflection in the white of the eye. This light is so even and soft that the differential in light intensity on her arms is almost indiscernible. The light literally wraps around her figure and arms as if it were caressing her skin, and even in the shadow areas there is good detail.

In plate 52, I have created a more traditional style portrait, again using the Spiderlite. The incredible evenness of this light makes this lovely model look her very best. Her skin tones are beautifully even, and the disparity in the light intensity across the image is imperceptible.

It is not my goal to promote any particular manufacturer's product, but the F. J. Westcott Spiderlite is innovative and meets a demand for this special type of light. The idea is not totally exclusive, as many of us have sought to create this type of light with various inventive ideas. If you want to go it alone and create this lighting effect, it may also be done using several fluorescent light tubes in a series with a diffusing screen at the front. But the configuration of this light is spot on.

7. Accent Lighting Techniques

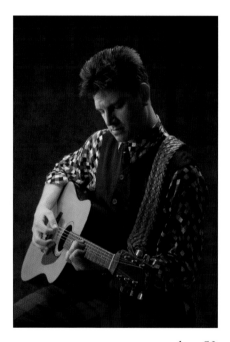

plate 53

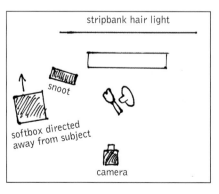

diagram 9

The style of portraiture that simply requires us to record a flattering image of a musician for publicity or for an album cover or book jacket generally does not permit us to be creative in capturing what the musician does. Rather, this style allows us little more than an opportunity to show what he looks like. Such images do not show the passion that goes with the music. In this chapter you will find some creative ways to portray this aspect of a musician's avocation.

In plate 53, the lighting used was selected to emphasize two dimensions of the artist at work. First, a snooted modifier was directed at his guitar to focus our attention to what the artist is passionate about. Second, I sought to show the depth of his passion for his music by separating the frontal and rear of his head to emphasize his concentration. In a sense this caused the image to have two distinct impressions at the same time. Had the total image been lit in the same tonal range, the portrait would not demonstrate his concentration. It would be an average portrait presentation.

The lighting setup consisted of a softbox turned away from the subject so only bounced light was directed toward him, and the snoot was directed only at the guitar. A hair light was used to rim the back of the subject's head and to light his hair. The effect introduces a feeling of another dimension. See diagram 9.

Plate 54 demonstrates a pause in the musician's commitment to his music and instrument. This was done both with the lighting and the composition. The lighting setup used to create this image was much like that used in plate 53, but the snoot was adjusted so that it skimmed, or was feathered, across the plane of the subject so the guitar did not appear too hot. Next, by turning the subject's head toward the camera a split lighting pattern was achieved, and this provided contrast and mood in the portrait. The image portrays strength as well as mood and maintains the important

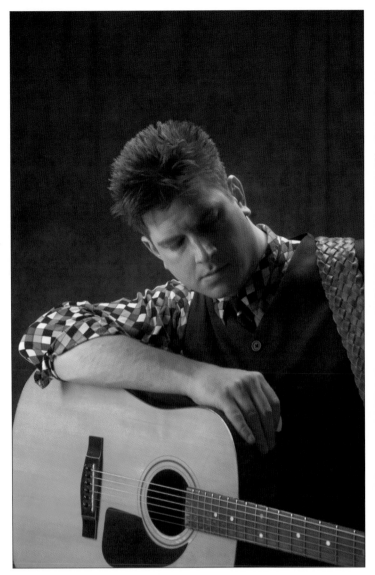

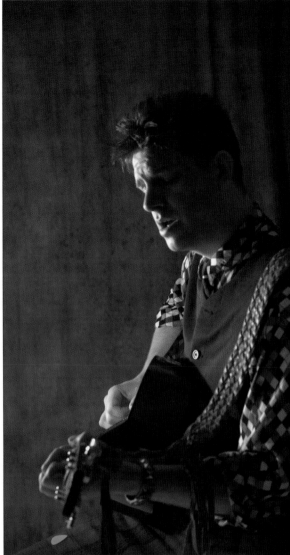

plate 54 *plate 55*

connection between the musician and his instrument. This image could readily be used on his album cover.

Plate 55 portrays action and shows how the musician is consumed with his music. The hair light used in the previous image was eliminated, and just the other lights were employed. The difference is that the snoot was skimmed, or feathered away and behind him, to ensure only a rim of light fell on his right arm and face. Compare plate 56 with plate 55 and you will see the difference in the impact of the two images. The greater illumination in the latter image reduced the impact and the impression of the musician's intensity and passion.

In plate 57, the technique of muting an image area to draw attention to that which is most important is demonstrated. The reflected light method was used as the overall lighting, and the snoot was directed to the musician's face. This technique allowed for the retention of the overall compo-

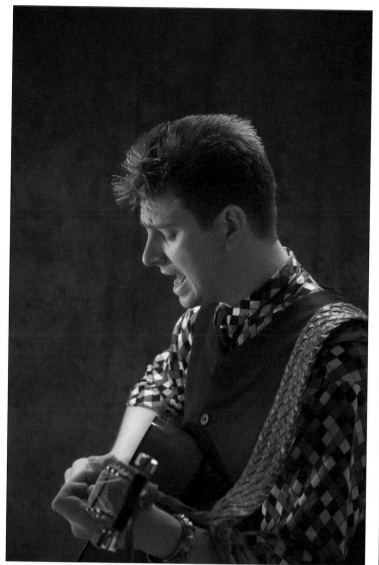

plate 56

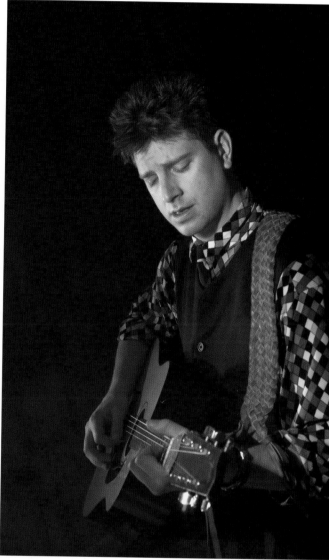

plate 57

sition while it focuses our attention on the character of the portrait. The images shown in plates 56 and 57 tell their own story about the musician.

The technique of focusing attention to an element within the composition was again used in plate 58 (next page). Kerry and Neil are engaged, and this is the oft-used ring shot, mostly done at weddings. As in the previous images, reflected light was used to softly light the faces of the couple. A hair light was brought a little farther over their heads to light the hands and ring as well as their hair.

Because their heads were slightly tipped forward, the light from above did not interfere with the lighting pattern on their faces. However, as with most hair lighting from above, the light has a little edge to it that adds a little more illumination to their faces. The only way to eliminate this spill of light would be to use a focusing spotlight, which is not a tool that is available in most camera rooms.

The lighting setup used here created a very intimate portrait of an engaged couple that is uniquely different from the engagement portraits we are accustomed to seeing.

The image shown in plate 59 has a totally different mood because only the reflected light described previously was employed. The snoot was eliminated and there was no hair light. The image is presented in a style that portrait artists virtually never use, yet it has a certain quality that appeals to some viewers' senses. It is the same type of light that you may see fleetingly in a room with very subdued lighting, such as in late twilight when there is no obvious light pattern, a scenario that would be difficult to record without an ISO of 3600 or by using a tripod for a long exposure. This shot was achieved with an ISO of 125 because studio flash lighting was used. So we have captured an image that is available in many situations but by a different method.

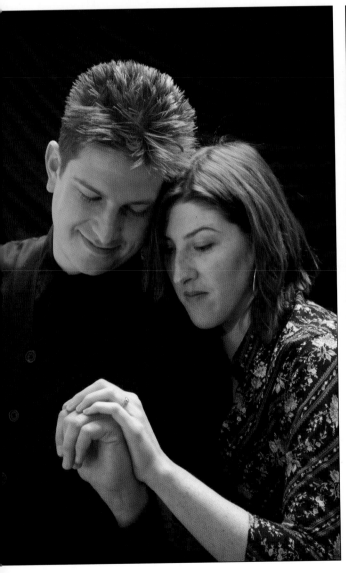

plate 58

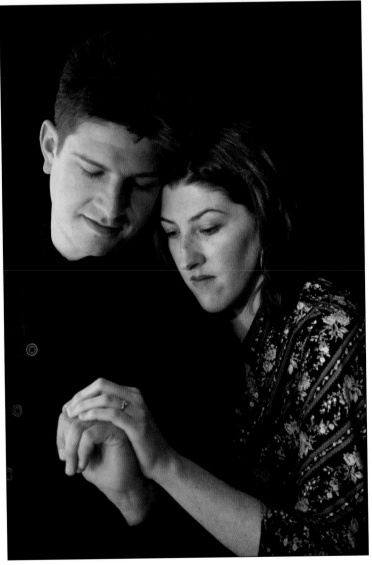

plate 59

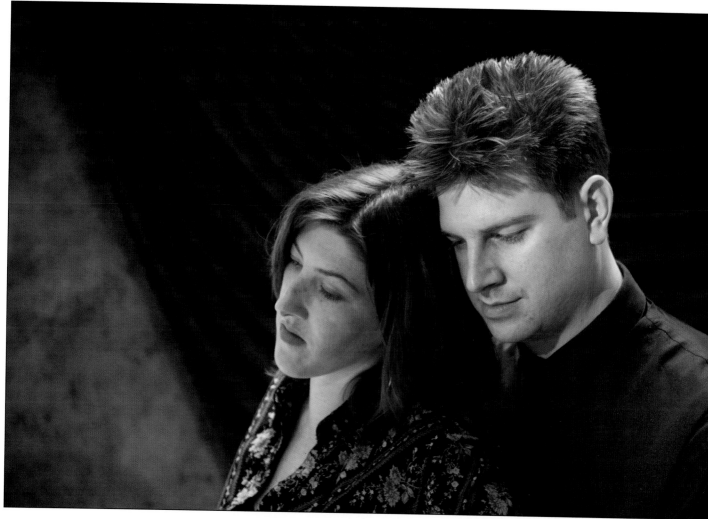

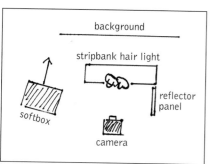

plate 60 (top)
diagram 10 (above)

Plate 60 proves that we can create different lighting patterns and impressions in the same image. The key light was the edge of a softbox slightly less turned away than in the previous examples, and a hair light was used to both illuminate the hair and light the male in the portrait. The hair light also separated the couple from the background.

Note there is a rim of light on Kerry and not Neil, because she shielded him from the slightly specular light from our left. To our right there is a white reflector panel, and this reflects enough light onto the male's left cheek to create a relatively traditional light form.

In creating this image I wanted to show how happy he was to have her resting at his shoulder, and I wanted to have her in a lighting pattern that showed her in an introspective mood. See diagram 10.

In the image shown in plate 61, the reflector panel at the right was removed, and Kerry was turned toward the camera so that she was lit in a manner very similar to Neil, except that he has a more masculine ratio as his left side falls into deeper shadow. The hair light was retained for separation and to create a little sparkle. The impression is one of quiet contentment in each other's company in a personal and private setting. The same

plate 61

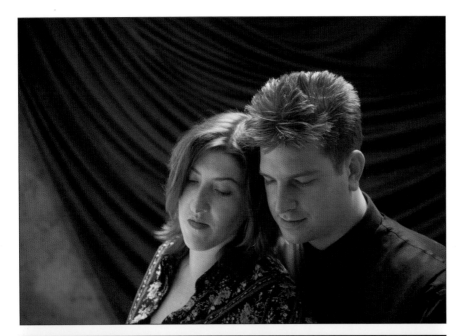

plate 62

portrait created with traditional lighting would not have the same romantic impression.

In plate 62, I chose to present the couple in reversed positions because I wanted to have Kerry in a different light pattern and to turn Neil slightly away from the light at our left. Kerry had her head very slightly turned upward to catch some of the light from above. This created a modeling of her face with delicate highlights on her cheek and a little kicker at her eyebrow. Note that because I turned Neil away from the light coming from the left he is lit with a very soft split lighting pattern that adds masculinity. While this portrait was not illuminated with lighting that would open up the eyes in the traditional style, you can see into the subjects' eyes, which have a little sparkle. I like to use the lighting features described above, as I

believe they add interest and vitality to the portrait, and you may well see this technique in other images in this book.

I have stressed mood and romance in previous image descriptions, and in plate 63, the image presents what I consider to be an impression of romance, and the mood of tranquility and comfort is emphasized by the lighting pattern and composition.

The one light used was a softbox, which was raised so that the bottom of the box was just below the subject's eyes and parallel with their position on the set. This high position allowed us to light the subjects' hair and create the lighting pattern on their faces. As you can see, Neil is again present-

plate 63

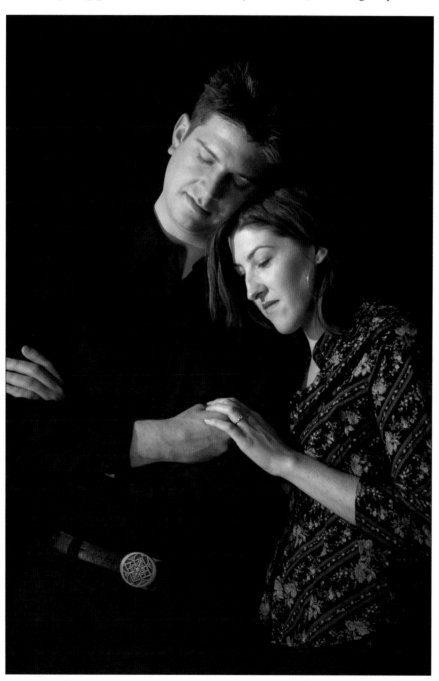

ed with an almost split lighting pattern. The little dab of light on his left cheek adds depth while Kerry is in a semi-profile pose. The portrait expresses contentment and comfort.

Note how the light in the image fades slowly into shadow so that the primary point of focus is the couple's head and shoulders.

In plate 64, without changing the pose and composition, the mood was immediately changed by turning the couple to look toward our left—without changing the light position. In this portrait there is a different dynamic as both heads were lit more dramatically. This added some pizzazz to what was previously a more tranquil mood.

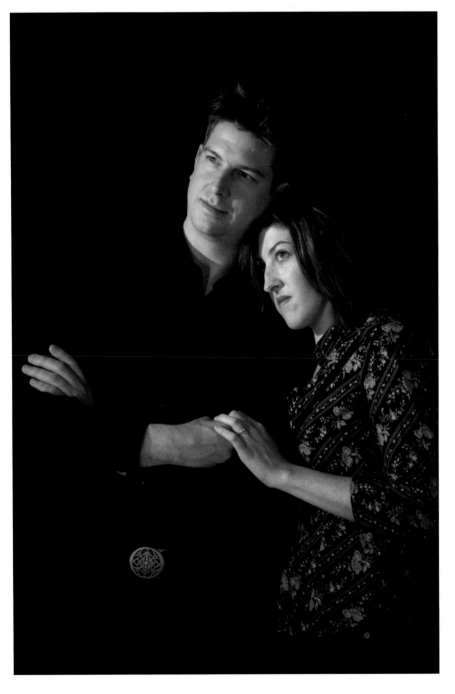

The little dab of light on his left cheek adds depth while Kerry is in a semi-profile pose.

plate 64

plate 65

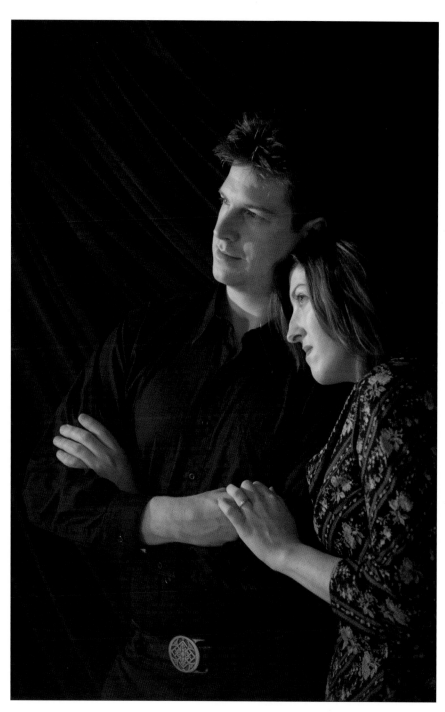

. . . the impact is greater as
the contrast has increased
across the composition.

Such simple changes not only affect the mood but also the expression, and we do not have to move or adjust our lighting. This is again shown in plate 65, where we have created a full profile of Kerry and almost the same of Neil. The light remains in this portrait as it was in the previous image, but because of the new angle of light to the subjects, the impact is greater as the contrast has increased across the composition.

8. Shaping with Contrast

I do not want to delve too deeply into the techniques we should use when we photograph women as I feel the subject is worthy of its own book, but there is some relevance in the context of this exploration of lighting techniques.

When creating portraits of women, portrait photographers are normally expected to render them in relatively soft tones with a minimum of contrast, something that the fashion photographer is much less concerned with. Yet if we peruse the pages of some fashion publications, we will see some very interesting and thought-provoking images. We could dare to say that the fashion photographer, in seeking images that help to sell their clients' creations, sometimes inadvertently produce some stunningly beautiful and exciting photographs. While some of these photographs have dynamic impact, they often neglect to shape the facial structure of their models in a manner acceptable to the portrait artist, and frequently the posing is unflattering and disjointed.

That said, we should consider the fact that the impact the fashion photographer created is worth our considering similar techniques in our portraits.

With lighting we can reshape our subjects' features to advantage or disadvantage. Carelessness can lead to images that do not flatter or otherwise render a beautiful woman in a way that is very unflattering. This consideration generally causes the portrait photographer to avoid high-contrast lighting. But as you will see in this chapter, we are able to show a beautiful woman in a provocative way with contrast lighting techniques.

In plate 66, we show our model attired deliberately in a black shirt with a neckline that exposes enough skin to a relatively bright light that barely holds her skin tones. This creates a base for a greater contrast lighting setup. This is also helped by the fact that the model is blond, so even before

If we peruse the pages of some fashion publications, we will see some very interesting and thought-provoking images.

plate 66 (left)
plate 67 (right)

 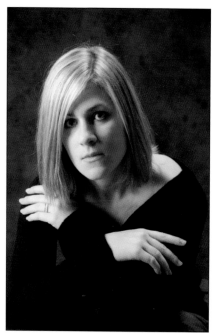

the lighting setup is in place, there is ample scope for a portrait with strong contrast.

Next, the model was posed her with her fair-skinned hands across her chest, providing more basic contrast. This might well suggest that we want to reduce the contrast, but instead we use it to create a dynamic, contrast-laden image.

Two lights were used to create the image. The key light for this image was a softbox with a single diffuser at the front with panels, attached to reduce the large softbox to an 18-inch strip of light. This directed some specular light from 60 degrees off camera and almost parallel with the model. The second unit used was a hair light that was positioned above and slightly behind the model.

The result is a strikingly beautiful portrait that has impact and lots of sex appeal.

The model was posed so that her head was tipped slightly downward with her eyes lifted toward the camera, which in turn caused her hair to block the key light so that her right eye appeared in shadow. This caused the light to create a very bright area of skin tones on the right side of her face and highlighted the very pretty nose line. The left side of her face fell into an almost 4:1 lighting ratio, yet the lighting that illuminated her left cheekbone was similar to that used to light the right side of her face. Some shadowing was created below her chin so that it was subtly outlined by a little reflected light from the light above, which also lit her shoulder. The hair light illuminated the hair perfectly. The result is a strikingly beautiful portrait that has impact and lots of sex appeal—proof that contrast, when planned, can make something extraordinary and attractive.

In plate 67, the model tipped her head slightly, and the impression of the image turned from seductive to inquisitive. The difference in the lighting is that in this image, it outlines the contours of the subject's eyes and

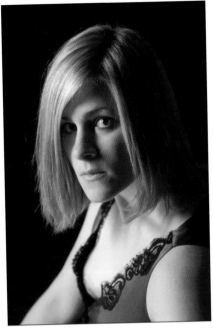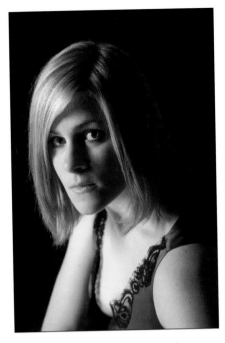

plate 68 (left), plate 69 (right)
plate 70 (facing page)

nose more precisely. The contrast range is similar to the previous images, but by tilting her head away from the camera, the lighting pattern was modified. This is a much more provocative impression than that achieved in the previous portrait.

In plate 68, the model is shown in attire with a lower-cut neckline that helped to increase the impression of greater contrast. The difference between this image and the previous two portraits is that we dispensed with the hair light. The model in this image was positioned in a three-quarter head pose, and again her hair acted as a block to the light, resulting in a deep shadow over her right eye. The hair blocking the light shaped her nose with deep shadows on the left side of her face but provided a flattering illumination of her left cheek and chin. Her hair appears well lit at the left of the image, and a little reflected light from a white wall some 6 feet to our right allowed us to sculpt the shape of her head. This lighting pattern draws the viewer's attention to the model's left eye, and her hair frames her facial plane. The image is profoundly feminine in a way that differs from the conventional style of female portraiture.

To create the portrait shown in plate 69, the model's hair was pulled away from her right eye to allow it to be illuminated. She turned her head very slightly away from the light to create a little more shadow on her left cheek, which automatically created more contrast. Because of the contrast, the viewer is drawn into her eyes, which are in the brighter areas of the lighting pattern. The slightly raised camera position also helped to create a different impression.

In producing the image shown in plate 70, my goal was to create a split lighting pattern with a little mystery in the subject's eyes. This was achieved by slightly feathering the light across her face so that we catch just a hint

My goal was to create a split lighting pattern with a little mystery in the subject's eyes.

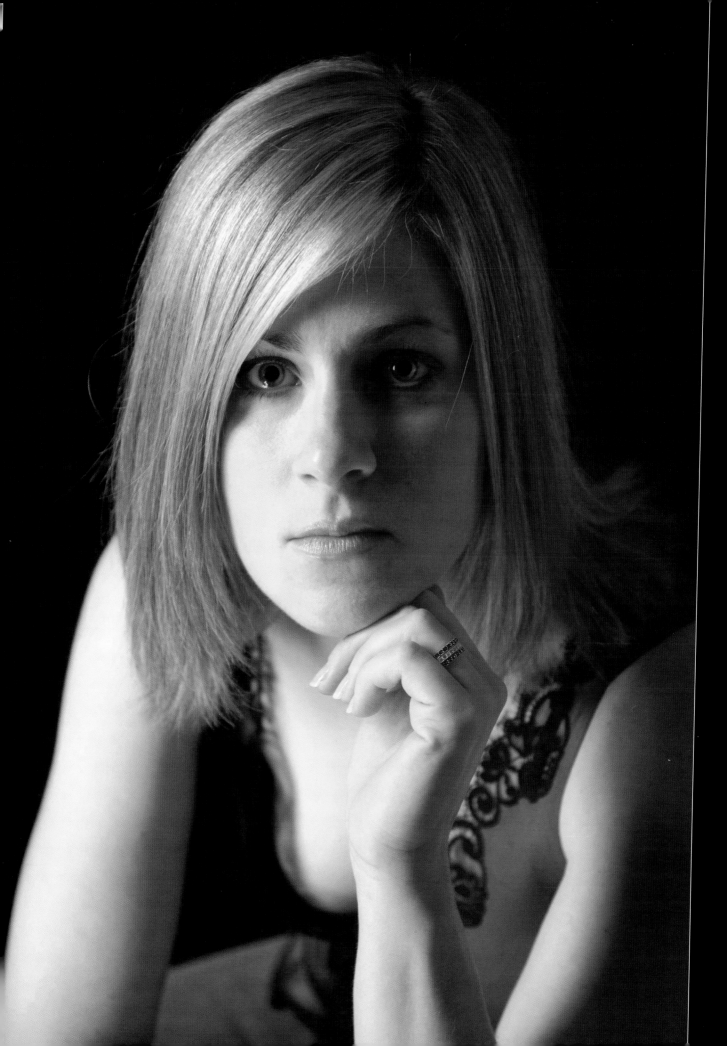

of light on the left cheek. This strategy also placed enough light in the left eye to almost match that in her right eye. The combination of contrast and subtle illumination in the shadows makes this a most unusual portrait with lots of interest.

Often we see our subjects in very simple terms and do not delve into who they are and what they may be thinking or inquire about their attitudes. This simple presentation is what most traditional portraiture tends toward. It does not cause us to see more deeply into the person in the image in the same way that the image shown in plate 70 demands. Portraiture is about more than just creating a flattering image.

Another technique that can produce interesting contrast is to light primarily from above the subject. It is a lighting technique that is generally frowned upon, but if it can be used to create more interesting images, why should we not use it to our advantage? The challenge with this form of lighting is to avoid creating deep-shadowed pockets under the eyes. This is achieved by having the subject very slightly tip their head away from the camera, as is demonstrated in plate 71.

The contrast in this image presents a greater than 4:1 ratio between highlight and shadow. But the image

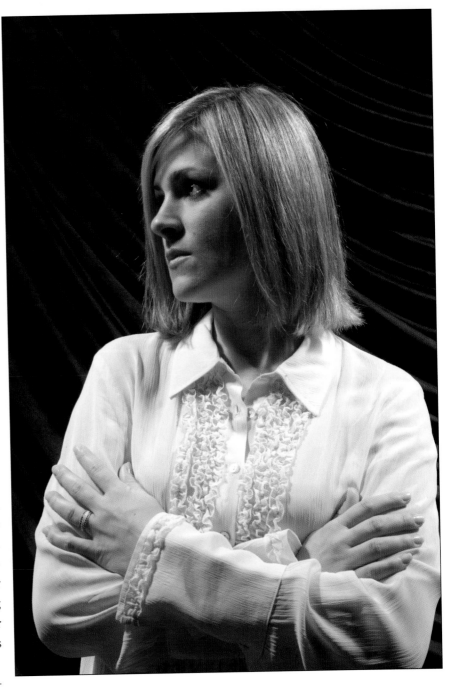

plate 71

is still attractive as we are able to see the subject's very lovely face in a profile pose. What helps make this acceptable is the light-colored blouse the model is wearing, which reflects light into the neck and chin, thereby creating a sculptured shaping of her head.

A mistake that is sometimes made with this style of lighting is to bring in a reflector below the subject's waist and reflect light upward toward the head. When not used with the conventional three- or four-light setup this light misshapes the modeling of the face, producing unflattering results.

9. Sculpting the Face

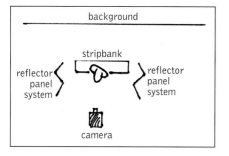

diagram 11—This diagram shows the lighting setup used to create the image series shown in this chapter.

The first consideration in conventional portraiture is lighting the subject's face to present them in a flattering and recognizable image. As was previously discussed, this requires the use of the prescribed three- or four-light setup. But the following series of images of Duane shows how we may present him in a number of different lighting patterns, each subtly (and later more dramatically) different from the last.

First, Duane was illuminated by a lighting setup that utilized only one light and two reflector panels. A diffused F. J. Westcott Stripbank, positioned above his head, was moved slightly for each consecutive image, and the reflector panels were adjusted for each image.

The reflector panels were made from sheets of 8-foot Gatorfoam cut into three 16-inch panels and then hinged together to create a concertina-style folding unit. They were painted black on one side and white on the other so the unit can be used for positive and negative lighting. To produce the first set of images, the white side of the reflector was used to create a wraparound field of light.

The 8-foot high panels were important in this series because we needed to produce a relatively large bank of light instead of a limited field that would have been produced by a smaller reflector panel or a disc. These panels enabled us to reflect light onto the subject from high above; had this been accomplished using banks of light from softboxes or umbrellas, the quality of light would have been very different. See diagram 11.

The reflected light from the panels rendered the soft skin tones that allowed us to modify the pattern with very small movements of both the subject and the panels. In plate 72 (next page), the two reflector units were positioned equidistant from the model on both sides as he showed a three-quarter face view. In this image you can clearly see the light coming from directly over his head. The fact that his head was slightly raised caused the

plate 72

plate 73

plate 74

light above to produce a hot forehead and nose. This kind of light pattern is one that you will see in many different situations and is usually less bright than what we have produced in the studio. The light from above also created sparkle in his hair.

Essentially this lighting pattern caused the image to present a very open facial view. It is not a very strong lighting pattern to use when we want to show strength in a masculine portrait. To subtly change this I simply moved the reflector system at my right a little away and turned it so that it reflected less light on the subject, but directed more light behind him. This immediately changed the impression. The result is shown in plate 73,

where you can see that the light on Duane's left cheek is significantly reduced, while the redirected reflected light now falls farther back toward his ear.

In plate 74, the right-hand reflector was pushed still farther back, and the image immediately gathered some additional strength, as there is now a more pronounced ratio, though still relatively short, and we have a hot ear from the light above.

To produce the image in plate 75, the right-hand reflector was moved farther away. This change eliminated the reflected light on the left of

The image immediately gathered some additional strength, as there is now a more pronounced ratio.

plate 75

Duane's face, thereby producing a more distinct ratio, though still short. Additionally, the light from above was moved a little farther back so that it no longer illuminated his forehead. These were relatively subtle adjustments, but they created a very different feel to the portrait. The effect was to reshape the lighting pattern, producing a more masculine portrait.

Using the same lighting setup in plate 76, Duane's pose was changed so he is pictured looking off to our left. This immediately changed the impression because there is an apparent lengthening of the lighting ratio, though in fact it has not changed. It simply allowed the angle of view to

This immediately changed the impression because there is an apparent lengthening of the lighting ratio. . . .

plate 76

The soft shadowing immersed the right-hand side of Duane's face, and the result is a stronger impression.

plate 77

enhance the impression by causing the light from our left to define the facial structure.

The image shown in plate 77 is distinctly different than the portrait shown in plate 75. In plate 75, we simply sought to create a pleasant impression, but in plate 77, we totally changed the impression without making a significant lighting adjustment. We simply had the model slightly tip his head, which automatically caused the light on the shadow side of his face to form a very soft split light pattern. The soft shadowing immersed the right-hand side of Duane's face, and the result is a stronger impression.

plate 78

To increase the strength of the
portrait another subtle
adjustment was made. . . .

To increase the strength of the portrait another subtle adjustment was made by moving the light from above a few inches farther behind the model. This shaped his nose in relief against the shadowed side of his face, as shown in plate 78. Having him rest his chin on his clasped hands further enhanced the impression of strength in this image. The same lighting pattern follows the leading lines from Duane's left hand through to his forehead.

Plate 79 shows our next adjustment, which was intended to further strengthen the impression by increasing the ratio and, at the same time, causing the light from the left of the camera to catch his left eye just enough to have it in relief against the deeper shadow we have created. The

reflector to our left was moved a little more to our right and slightly farther back. This created a modified split lighting pattern by allowing a little illumination to the left side of the face behind the model's cheekbone and also provided a touch of light to the left side of his nose. This produced an enhanced appearance of depth and strength for a strong, masculine presentation.

One of the key features of this style of lighting is that it allows viewers to look into the eyes of the subject in a way that conventional lighting does not permit. Each of these images is virtually without a distinct catchlight.

Each of these images is virtually without a distinct catchlight.

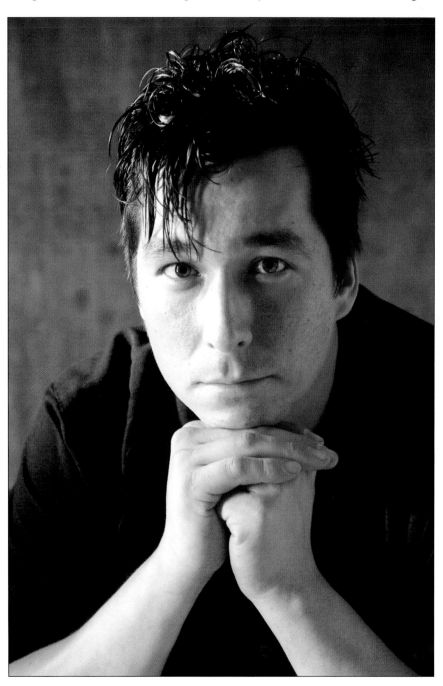

plate 79

This seems to open the eyes of the subject so that viewers can appreciate the character and personality of the person in the image. When catchlights are present, the viewer is more likely to see the subject in a less personal perspective.

Almost exclusively our modeling light shows what lighting effect we can expect to achieve in the final image, so the result of making this subtle adjustment of the light can be seen before the exposure is made. This shows that when we are patient and make only very small adjustments to the position of either the subject or the light we can create very different impressions.

These eight portrait examples have demonstrated that with just the hair light and reflectors at the sides of the subject it is easy to modify lighting patterns.

Our modeling light shows what effect we can expect to achieve in the final image. . . .

10. Mystery and Drama

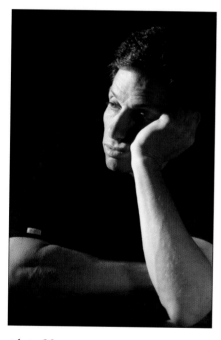

plate 80

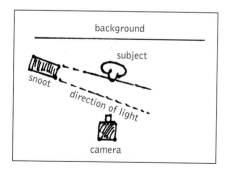

diagram 12

In the previous chapter we discussed the use of primarily reflected light. In this chapter I will show you how to use a similar lighting pattern to produce images with greater drama and a little mystery.

In plate 80, Larry is the model. I sought to create an impression of both mood and strength in the image by lighting his arms in two different styles. I wanted to produce a strong leading line that would draw viewers to his face, and to present his other arm in a less obvious but supporting position. These two elements created the frame for the portrait, which shows him in an introspective mood, possibly disconnected from the viewer. This portrait was created using a snoot, which was directed from our left to cut in strong relief the shape of his face and just catch his left eye to create a connection with his right eye, which appears slightly mysterious.

The composition is triangular as his left arm and his head angle form the apex of the composition. The hard light provided by the snoot combined with the black background and the deep shadows dramatically enhanced the impression of his mood, yet the masculine strength I sought to record is very demanding.

In the portrait shown in plate 81, Duane is again our model. The key light was a snoot supplemented by a reflector. The snoot was positioned to the left of the camera and a little behind the subject's plane to the camera, and slightly above the top of his head. The light was also slightly feathered so that it skimmed across the front of his face. See diagram 12.

The dark-colored background was not illuminated, which created dramatic contrast between the lighted subject and background. To the right of the camera was a white wall that reflected a little light from the snoot back onto the left side of the subject's face. The effect is similar to that in the portrait examples shown in the previous chapter, but the contrast in this portrait is much greater.

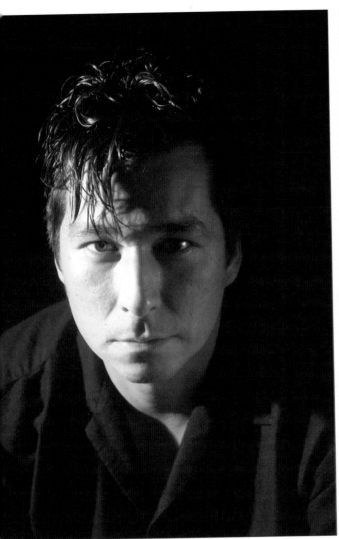

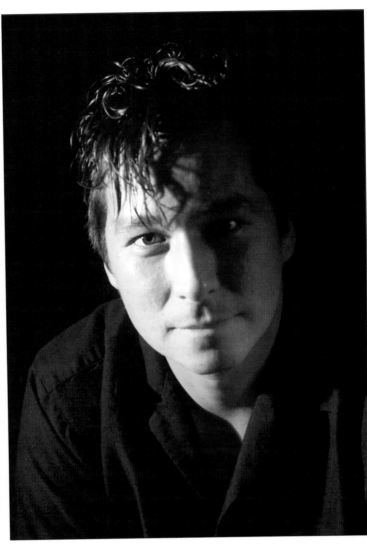

plate 81　　　　　　　　　　　　　*plate 82*

This light modifier has a unique ability to both concentrate the light into a relatively small field but also to cause light to illuminate a small field beyond its area of concentration. In this portrait, you are able to see this effect on the shadow side of Duane's face, as the snoot very slightly lit the left side of his nose.

The same ability of this modifier also directed just a hint of light onto his left eye. The effect is an impression of both contrast and mystery as the light in the subject's left eye created a second area of interest to the rest of the lighting pattern. The slightly raised position of the snoot also illuminated Duane's hair so that the overall roundness of the lighting was maintained. The result in the image, once again, was a modified split lighting pattern.

We can use this style of lighting to create very different moods. Compare plate 81 with plate 82. The image shown in plate 81 has a very severe, almost depressive expression that is well suited to this type of lighting, yet

in plate 82 the model has a very friendly expression that is also very masculine.

Consistent with the lighting used in the previous chapter where we sought to eliminate catchlights in the eyes, this lighting style achieves the same result. When we avoid catchlights in the eyes we are, so to speak, looking into the soul of our subject as the eyes absorb our interest in a way that is not possible when catchlights are there.

To produce the image shown in plate 83, the snoot was retained in the same position as in plate 82. A silver reflector was brought in at the right of the camera to virtually duplicate the lighting on the left side of the model's face. But because the reflector's light was also feathered it did not light this side of the face as accurately, allowing us to create a shadow on his cheek between his nose and the side of his face. The effect is to create a lighting pattern that is somewhat unique in photographic portraiture. It enhances the question in his expression. This emphasizes that we can use

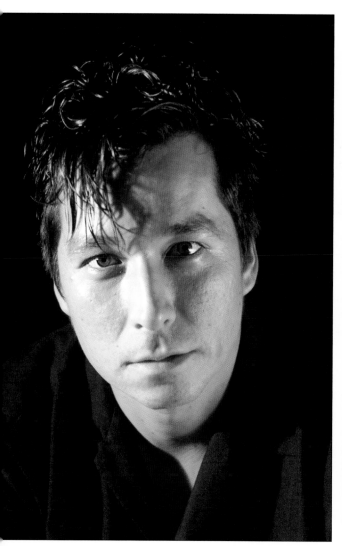

plate 83

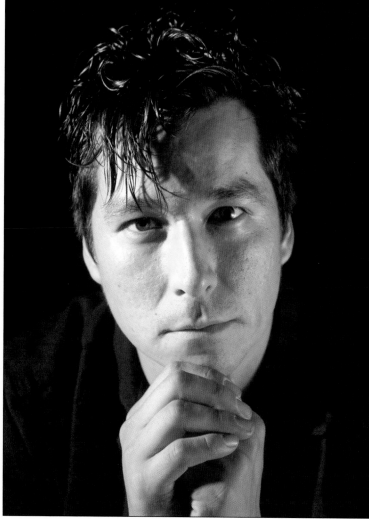

plate 84

lighting to both create mood and enhance the attitude the subject presents to us. This is demonstrated in plate 84. Using the same lighting setup, we posed our model in a more challenging manner. The lighting does not light the hands at our right, which draws us directly to his expression.

This is a very strong masculine image. The lighting was designed to create an unusual, nontraditional impression that sets it apart from what you would normally expect to see in conventional portraiture.

The lighting technique used in these latter images can also be used to create what can, in photographic terms, be described as three-dimensional, as two zones of light are created. We are able to use a single light and a reflector to create two separate light fields in the same image and create depth and drama at the same time.

In plate 85, Duane was positioned and lit as he was in plate 81. Kerry was positioned behind him so that the illumination from the snoot that fell on her was approximately 1½ times less intense than that which fell on him.

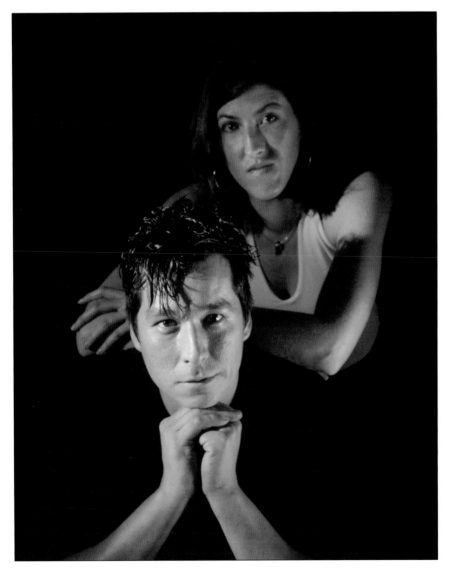

Kerry was positioned behind him so that the illumination on her was less intense than that which fell on him.

plate 85

This could be described as a kind of zone system. This creates the impression of an additional dimension and is a unique form of lighting very rarely used in portraiture. The lighting pattern on the female in the background is less precise than we would normally expect, yet it is intriguing. In effect we have retained the dynamics of the strong masculine lighting on the male subject and created a secondary lighting pattern on the female in such a way that while we are struck by the strength of the male we are drawn into the image to seek out the female. This is an image with a much more fine art impact than a conventional portrait feel. It presents two distinct impressions in the same image.

In producing the image in plate 86, the same technique was used—but with a subtle difference. In this image the models have switched places so

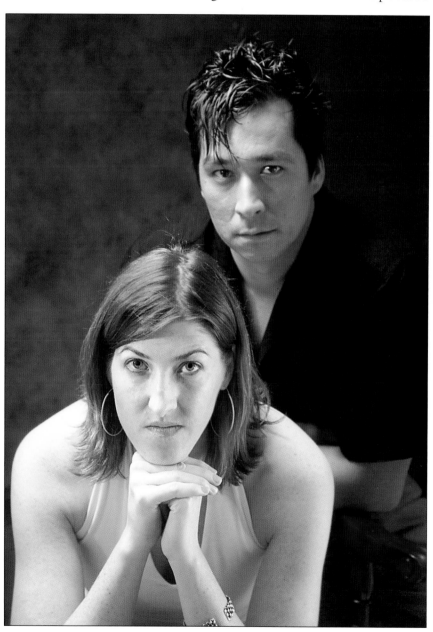

plate 86

that the female is positioned in front and the male is behind her. The goal in this portrait was to present the female in a more feminine lighting pattern to show more delicate skin tones. At the same time the male figure appears slightly closer to the woman than he was in plate 85, but nevertheless he is in a reduced light field, which creates another dimension. In the conventional style of portrait he would be expected to be at her shoulder so that both heads would be within a few inches of the same point of focus.

11. Reducing Head Size

If you will return to plate 23 (see page 29), a portrait of two young women, Jean and Amy, you will note the difference in the shape of their heads. Amy, seen on your right, has a wider facial structure, while Jean has a smaller and more rounded structure. Additionally, Amy is longer from her cheekbone to her ear than her companion. This is emphasized in the image shown in plate 87, where the women are presented in semi-profile.

The respective position of the two women in this image does not flatter Jean and increases the disparity in the size of the subjects' heads. This is

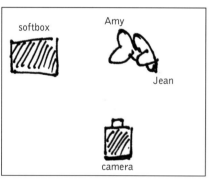

diagram 13—Note that Jean is behind Amy's plane to the camera.

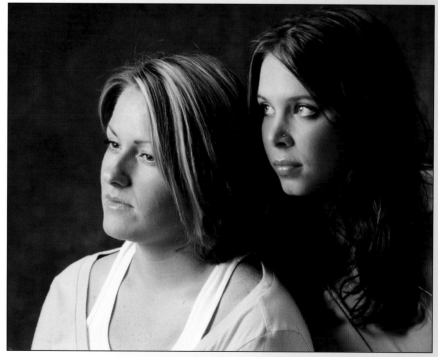

plate 87

because the key light creates a shorter ratio from highlight to shadow of Amy, while the ratio is significantly longer on Jean. If the two women had the same ratio, it would slightly reduce the disparity, but not enough to create the most pleasing rendering of their faces within the same portrait.

The reason why this image draws attention to this disparity is because Amy is positioned farther from the light than Jean, and she is also a little nearer to the camera. These two factors cause her to receive less of the specular light.

Now look at the image shown in plate 88. The figures have been reversed so that the same basic lighting pattern changes very slightly because the subjects are rendered in a more profile view. This change slightly reduced the disparity between the shapes of the two subjects' heads, as there is a longer ratio on Amy, which is more flattering than the result shown in plate 87. But the trick is to render both women in as flattering a light pattern as possible without altering their individual facial

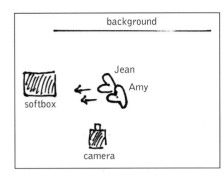

diagram 14—Note the proximity of the pair and their angle of view to the camera.

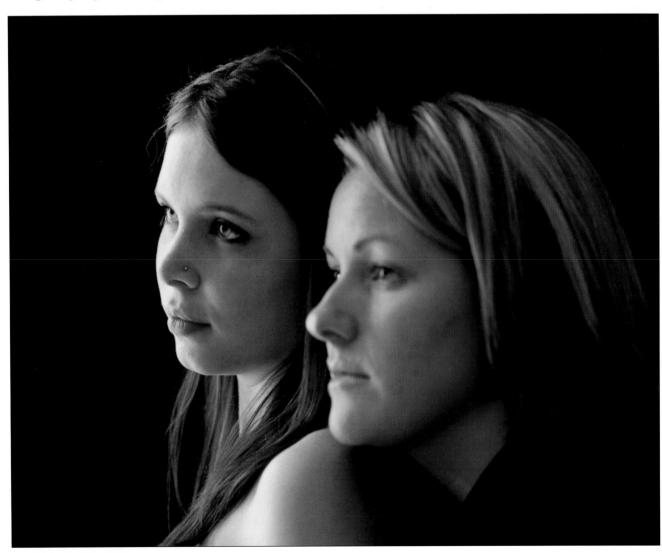

plate 88

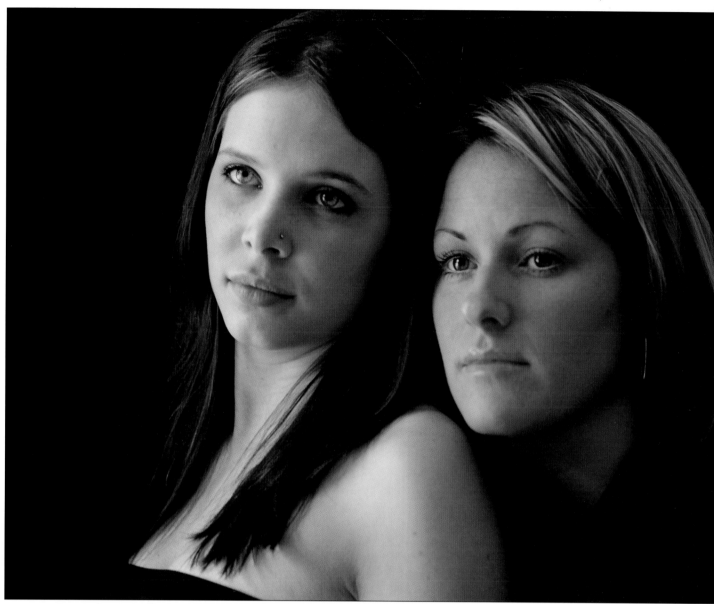

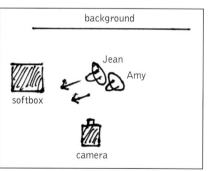

plate 89 (top)
diagram 15 (above)—Note the
change in the angle of view.

structures in a way that would be unrecognizable. The exercise is not to change who they are but to present them as they would like to be seen.

This goal is achieved in the portrait shown in plate 89. Both subjects are positioned in a three-quarter facial pose that presents Amy in a much more flattering light. The left side of her face is now in a soft shadow that creates the impression of a shorter distance from nose to ear. At the same time the kiss of light on Jean's left cheek slightly widens the distance from nose to ear. Now there is less disparity between them.

Remembering that the brighter any part of an image, the larger it appears is the reason for reducing the brightness on Amy. By rendering Amy in more saturated skin tones, we have created the impression of less mass.

See diagrams 13, 14, and 15 as they relate to plates 87, 88, and 89.

12. Creating Sex Appeal

While this book is not about the art of photographing women, there are some creative lighting techniques that can be used to stretch the female portrait into another zone. The term "sex appeal" creates the notion of lots of bare skin and other forms of exposing the female anatomy. But sex appeal is much more than bare skin or suggestive poses. One of the key elements in the invitation to advance the male–female relationship is the intonation in either of the sexes' verbal communication. But the visual communication between the sexes often requires no verbal interaction at all. It is implied in the way the eyes of the parties communicate, and when expressed in the ideal lighting situation it can be too much to resist.

Many photographers have made a good living in boudoir portrait photography. Most of what I have seen has much to do with drawing the attention of the viewer to the female anatomy (which is most often scantily clothed) and frequently misses the point made above. There are very simple lighting techniques that will prove my point.

Plate 90 shows a woman posed in a very simple head shot. Her attractive smile made for an image that her husband or boyfriend would appreciate as a keepsake or to place prominently on a mantle. The lighting was provided by a 24-inch umbrella placed at about 50 degrees to camera right with the flash tube at eyebrow level, which provided light on the subject's hair. There was no fill light used and just ½ stop of hair light. This is the simplest of lighting setups and does not meet the required lighting pattern normally produced for such a portrait. But the adjustment made in plate 91 produced a dramatically different impression. By turning the model 15 degrees farther from the light and tipping her head toward the shadow side of the lighting we achieved an image that implies something very different from that shown in the image in plate 90. The expression in the subject's

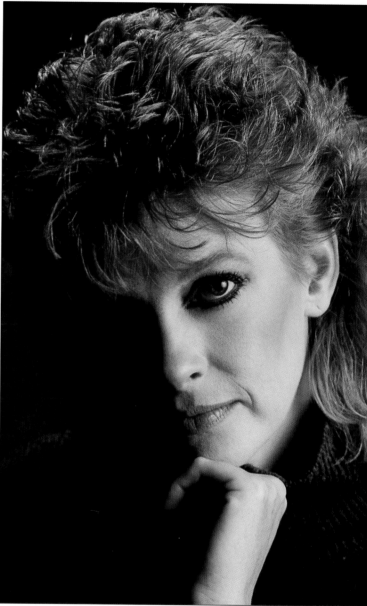

plate 90 *plate 91*

eye(s) could send a very interesting message to the significant male in her life.

In producing this portrait, it was my goal was to prompt the viewer to look deeper into the subject's eyes. The image is not as openly presented as is the portrait shown in plate 90; rather, we are drawn into it. It is an example of using light—or the lack of it—to send a message that other lighting patterns do not.

A lighting pattern we can call "wrong side lighting" was used to create the image shown in plate 92. This lighting pattern is similar to a Rembrandt portrait because the key light is directed to the side of the face that would traditionally be mostly rendered in shadow. But in this image

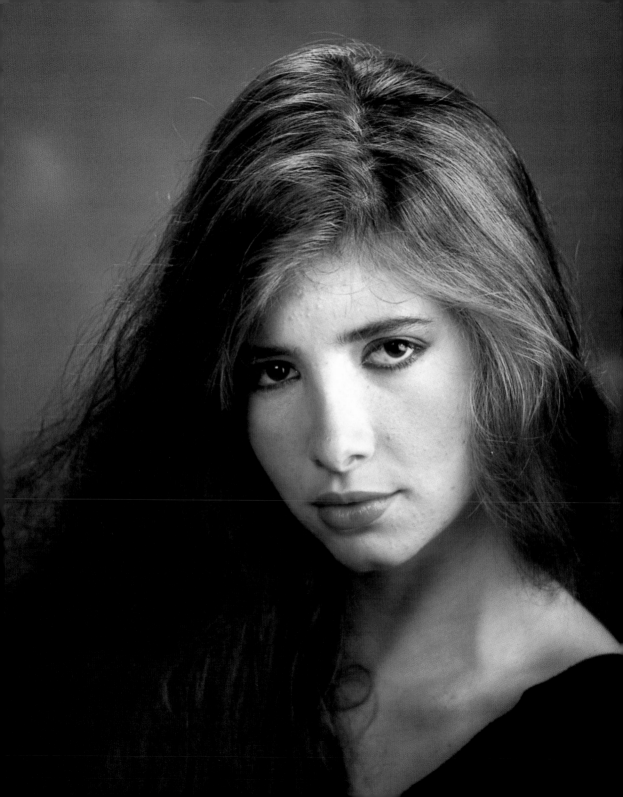

plate 92 (facing page)

the expression in the eyes of the woman was enhanced by creating the portrait in a 3½:1 ratio.

The light used was a 24-inch umbrella, because the light from umbrellas tends to wrap around more than that from softboxes, and it was important to have just the right amount of light on the shadow side of the subject's face to draw us into her eyes. The light enhanced the shape of her lips, which was needed to complete the impression that she is daring us to approach her. The image is very seductive and much more interesting than a straightforward invitation.

Plate 93 presents a softer yet just as dramatic impression that is no less alluring. This portrait was lit so that the beauty of a great head of blond hair was not lost.

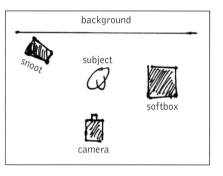

diagram 16 (above)
plate 93 (right)

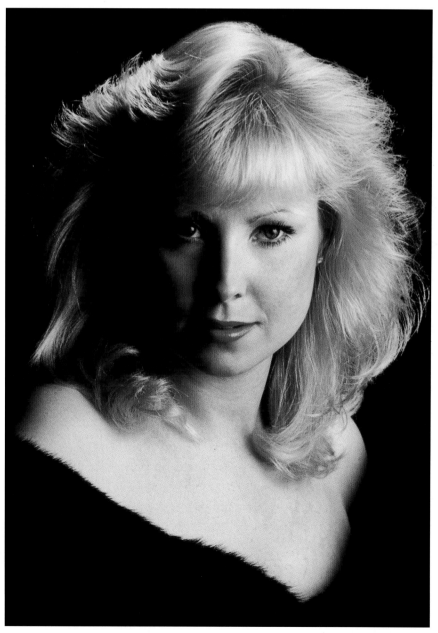

The difference between this portrait and that shown in plate 92 is that the two subjects are very different women and need to be presented as such. In creating this portrait I used a softbox with an 18-percent gray interior and a snoot to illuminate the shape of her hair. The snoot was directed from a high point behind the model and to our left so that it would not interfere with the lighting pattern but would produce enough illumination to edge-light the full shape of the hair.

The softbox was placed 15 degrees off the subject and slightly feathered away from the camera so that it fully lit the model's hair and provided just enough light in the shadow side of the face to pick up her right eye. This also provided a touch of light to her hair on her right shoulder, which added to the softness of the nevertheless dramatically lit portrait. See diagram 16.

Plates 94 and 95 show two different impressions of the same woman, both of which have an abundance of sex appeal. The image in plate 94 was lit with multiple lighting units. The first was a 30-inch umbrella placed at approximately 50 degrees off camera with the flash tube at forehead level to create the lighting pattern on the model's face. Positioning the light in this manner also illuminated the front of her blond hair and caught her left shoulder. A second umbrella was positioned a little behind the model and directed at the back of her head and shoulder to create an almost three-dimensional lighting effect. Finally, a snoot was positioned behind the model to create an overall glow of light to her hair. See diagram 17.

Our model rested her head against a black, fabric-covered pillow to achieve the maximum contrast between the skin tones and her blond hair and also the background. The modeling of the subject's face provided very feminine contours. The overall effect is a very sensual portrait with an expression that has lots of sex appeal. The cross lighting that was used is unusual and creates a feeling of depth that you may think you could place your hands around.

In plate 95, we made two adjustments. First, I had our model slightly turn her head away from the key light, the 30-inch umbrella with the flash tube positioned at forehead level, to our left and tip it a little forward to change the pattern of light. Next, the light at our right and behind the model was feathered away from her to eliminate the light that created the precise modeling to the left side of her face in plate 94. This allowed me to create a different lighting pattern to the left side of her face, bringing it slightly into shadow. This changed her attitude toward us quite dramatically. We now have a very different impression as the lighting now renders her in an even more seductive expression. The adjustments are relatively simple and easy to achieve yet we have transformed the portrait into a softer impression.

Sometimes we overemphasize the need to show more than the eyes of our subject in order to create sex appeal. Yet the eyes do just that. We send

The modeling of the subject's face provided very feminine contours.

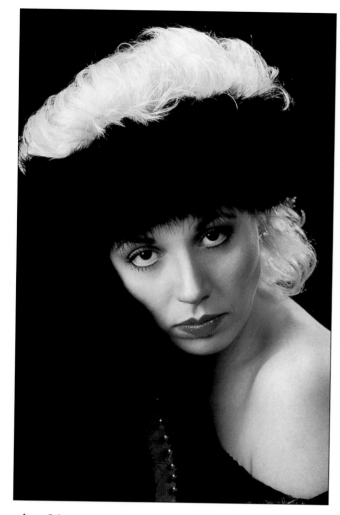

plate 94

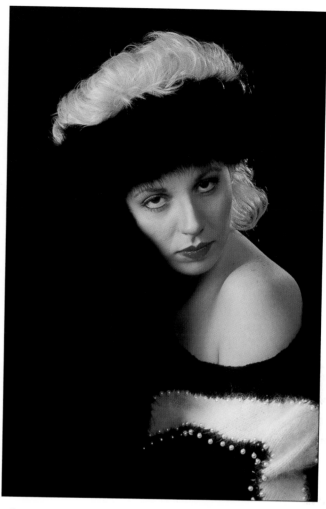

plate 95

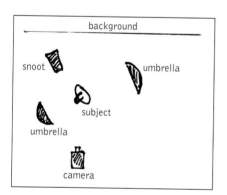

diagram 17

more messages with our eyes than with just words, and this is most true in regards to the female.

In plate 96, we have a close-up portrait that was created using a Bowens MystiLite, a softbox with an 18-percent gray interior that allows for the softest of light. The light is so soft that we are able to position the box within inches of the subject without burning out the skin tones. In this example the box was just 15 inches away from the subject's left side.

This close proximity of the softbox to the subject was important because, had it been farther away, it would have illuminated the side of her face and her hair instead of just the mask of the face. This was the only light on the subject, and the only other light used in the setup was directed at the background to create a little separation.

The light from the softbox was feathered across the face of the young woman from a fairly oblique angle with the aim of simply isolating her face from any other element in the composition. The effect was to produce an image with great depth and tone with extraordinary sensual—but not necessarily sexual—appeal because we are drawn into the eyes of the subject.

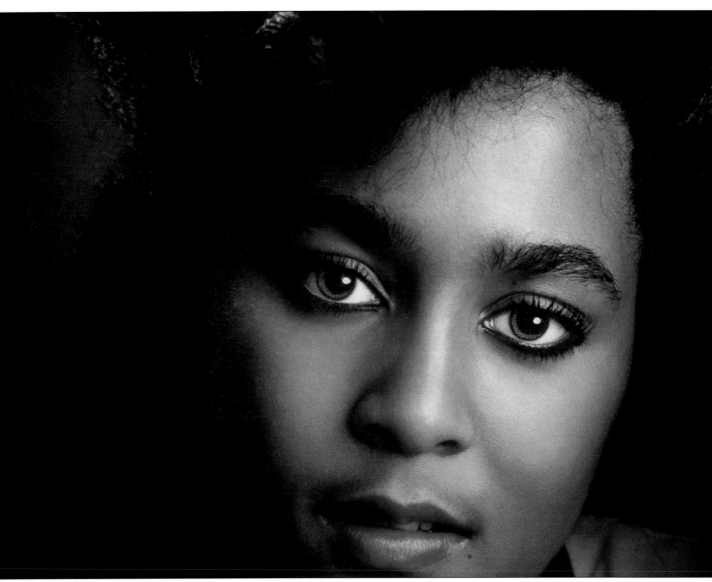

This simple lighting technique is never employed because portrait photographers do not consider using less than three lights to illuminate their subjects and may then also use a background light. See diagram 18.

In plates 97 and 98, the same young woman is rendered in subtly different impressions. The portrait shown in plate 97 has a certain sensual appeal. While it conforms to the basic guidelines for using a key light as accepted in conventional portraiture, no fill light was employed. The key light, a Bowens MystiLite placed at about 50 degrees to the subject's right, feathered across her to light the mask of her face while gently lighting the hair that framed her face. There was a little reflected light from a white wall in the camera room that slightly picked up her hair at the right side of the photograph. This image was created as the basis for the portrait shown in plate 98.

In the portrait in plate 98, I had the model slightly turn to face the camera and tip her head a little to her left to change the lighting pattern, caus-

plate 96 (top)
diagram 18 (above)

ing the left side of her face to fall into shadow. This change immediately created a much more sensual impression. This is because her left eye is rendered almost completely in shadow, yet there is just enough light in the eye itself that we are drawn to it, making it a significant element in the overall portrait. This technique could be described as creating two separate forms of eye contact that work together to create greater interest than had both eyes been equally illuminated. The difference between the two images is quite striking, yet the change in the lighting is very slight.

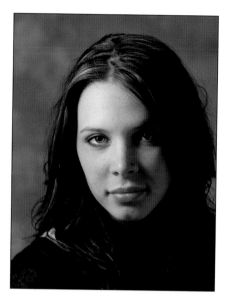

plate 97 (above)
plate 98 (right)

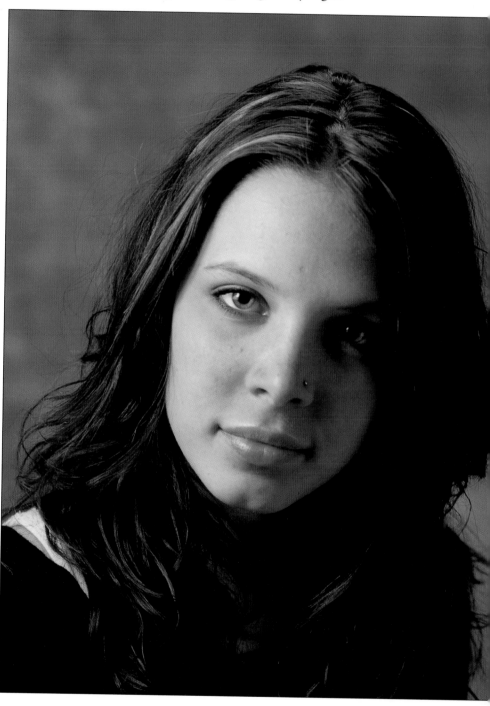

13. Children's Portraits

plate 99 (facing page)

While this is not a book about photographing children it is useful to discuss one or two ideas that either create something unusual or require special lighting techniques in order to produce a specific result.

In creating our images, most of the challenges we face do not require complex lighting setups; rather, we must employ very simple solutions based on our knowledge of the lighting equipment available in our camera room.

An example of an image that we might deem unusual is shown in plate 99, a portrait of a small redheaded child. When I was introduced to this young subject I readily recognized she was a little person with a special personality. While I naturally produced a more conventional set of images for her parents, I set out to create something very different—something that my peers would probably see as inappropriate, as we normally do not photograph small children in stark, low key settings. But the very unique character of this little person inspired me to produce this portrait in strong relief against a black background.

The single light used was a 24-inch umbrella set at f/8. The umbrella was placed at a 40-degree angle from the child, which is also 50 degrees off the camera. The light was slightly feathered upward from the umbrella to create a little vignette. The effect is a very unusual image of a child, yet it is dramatically effective as it shows in stark relief her red hair and pugnacious personality.

Producing a portrait in which a child appears to be reading by the light of a single candle, like that shown in plate 100, requires the photographer to know just what kind of light to use. Because using only the light of a single candle would require a very long exposure, I recognized that I would need to add more light to counter any potential movement by the

. . . it is useful to discuss one or two ideas that either create something unusual or require special lighting techniques.

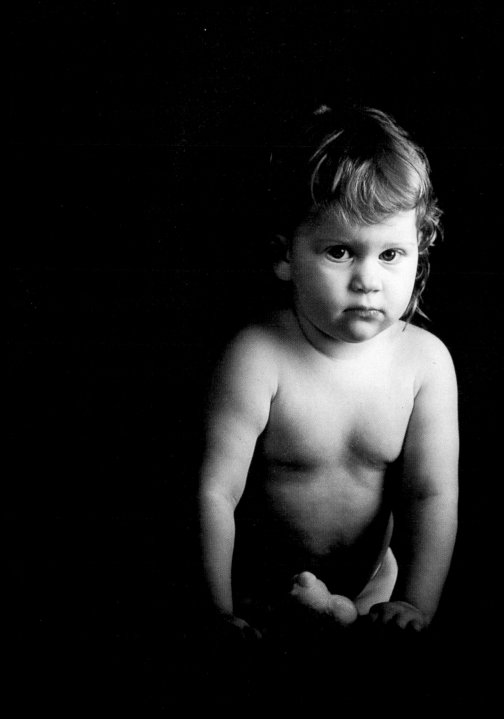

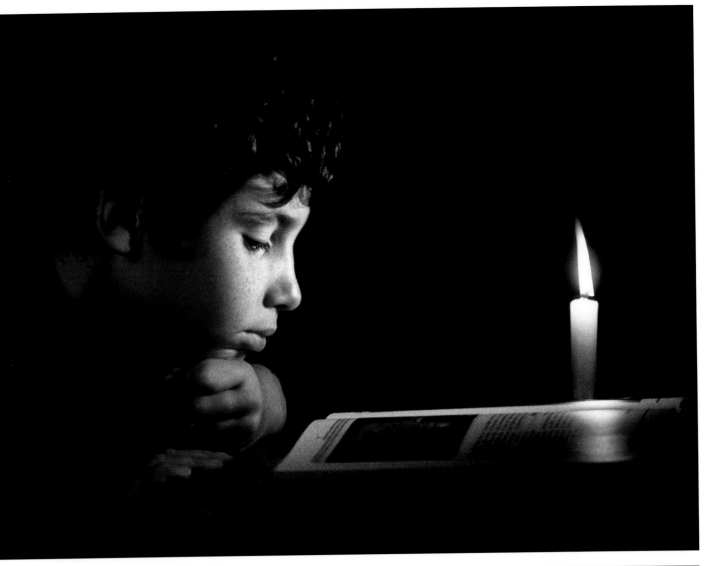

child. A candle provides a very specular light that does not create a wrap-around effect, as would even a single electric lightbulb. Therefore, in order to replicate the light of the candle, I had to select a specular light source, so my choice was a snoot.

Before directing the snoot it was necessary to first carefully observe how the light from the candle illuminated the boy reading the book, then to reduce the intensity of the light from the snoot so it would be similar to that emitted by the candle. Next, the snoot was employed so that it matched the lighting pattern of the candle. This required the snoot to be positioned just behind the plane of the candle and directed at the far side of the boy's face.

Once this was achieved the intensity of the snoot was increased to enable an exposure of f/5.6. I calculated that this f-stop would likely be required in order to realistically render the candle, and I was correct. The next step was to spot meter the candle to ascertain the length of the exposure, and I decided on a shutter speed of $\frac{1}{30}$ second at the chosen f-stop. This same

plate 100 (top)
diagram 19 (above)

f-stop also recorded sufficient illumination to the near side of the boy's face, which was observed when matching the light pattern of the snoot to that of the candle. The result is a very realistic replication of the composition before the introduction of the snoot. See diagram 19.

Over time I have seen numerous portraits in which the photographer attempted to capture children with bubbles. Mostly, the bubbles were barely visible because they merged into the background or the angle of the light was too flat as it related to the child and the bubbles. Additionally I have noted that in a color portrait of this kind there was little or no reflected color in the bubbles.

To overcome the color issue when photographing bubbles, we have to ensure that the angle of light illuminating the bubbles is parallel with the subject, and there should also be a bare minimum of light on the camera side so as not to overlight them. In plate 101, the key light is a softbox positioned to provide light that we use for profile portraits even though the child may not necessarily be in a profile pose. The normal fill light that

diagram 20 (above)
plate 101 (below)

would be approximately 1–1½ half stops less than the key light is reduced to less than ¼ of a stop so that its effect is barely discernible. This was achieved by bouncing light from the fill source, an F. J. Westcott Halo Mono, off a side wall that was parallel to the camera.

This allows the colors of the child's skin tones and the white in her dress as well a little of the background colors to be reflected in the bubbles, creating vitality and sparkle. Had the fill light been employed as for a normal portrait it would have reduced the color in the bubbles and blurred the outline of the bubbles. See diagram 20.

Plate 102 shows another portrait in which babies are seeking to catch those elusive bubbles. To ensure that the bubbles were captured as the little people would see them, a very simple lighting pattern was used against

plate 102

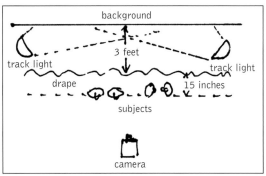

plate 103 (top)
diagram 21 (above)

a solid black background. The light was a 24 x 32-inch softbox, positioned to the right of the camera. The light produced almost a 1:1 ratio that ensured a relatively even coverage across the plane of the camera and the composition.

Because bubbles are basically water they will reflect light and, against a black background, will be clearly defined. While additional lighting on this set would have likely created an improved lighting pattern on the babies, it would have reduced the clarity of the bubbles.

In plate 103, we reverted to a high key lighting setup with the aim of achieving delicate tones that creates a very feminine impres-

sion. All of the lighting in this image came from the lights projected onto the background.

The basis of this lighting setup was the standard high key formula. The intensity of the light projected onto the white background produced f/16 at an ISO of 160. To reduce the specular intensity and soften the lighting on the dancers an opaque drape that effectively reduced the light intensity by almost 1 f-stop was placed 3 feet from the background behind the girls.

Normally, the exposure on this set would have been based on a key light setup for an exposure of f/8, but the normal key light was not employed, and the image was created with the same f/8 exposure. The significant field of light provided by the reflected light acted very similarly to what we would see from a large window with slightly diffused sunlight. The light wrapped around to render delicate skin tones and at the same time produced a delicate outline of the girls without them merging into the light field. At the same time their delicate net skirts were not lost in the light, and there was also an adequate modeling of the faces. See diagram 21.

The light wrapped around to render delicate skin tones. . . .

14. Wedding Images

I have dealt with some wedding ideas in plates 18, 19, 20, 24, 33, 34, 35, and 36, but each of those examples simply demonstrated the different ways we can use natural light that is available to us. In this chapter I want to cover styles and ideas that are appropriate for wedding portraits because of the romantic concepts we will employ.

In plate 104, we see a bride photographed in early sunlight against a white stucco wall. I had previously seen this particular wall in the early

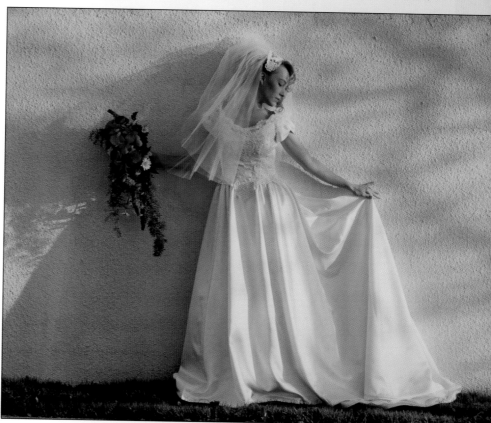

plate 104

sunlight, and I had the idea to use it if the same conditions were available and appropriate.

The light captured in this portrait was very directional, streaming from my right and creating a pattern of shadows on the wall from the branches of a tree. The goal here was to create a romantically elegant image using the shadows from a design perspective and employing the directional sunlight to create long shadows behind the bride, while at the same time producing a relatively long ratio from highlight to shadow on her face. Because the light skimmed across the bodice of the gown it beautifully rendered the delicate embroidery. The directional path of the light dramatically enhanced the beauty of the gown and also created a long shadow on the wall behind her that creates additional interest in the composition. It is a style that many purists will frown upon, yet the image has a distinctly artistic look to it.

In plate 105, the power of direct sunlight was again employed, but in a very different way. The bride and groom were placed where there is no hot

plate 105 (below)
plate 106 (facing page)

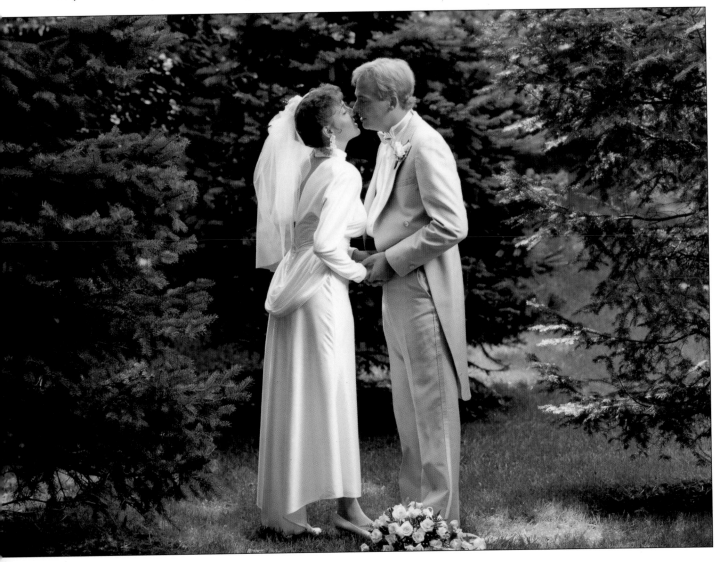

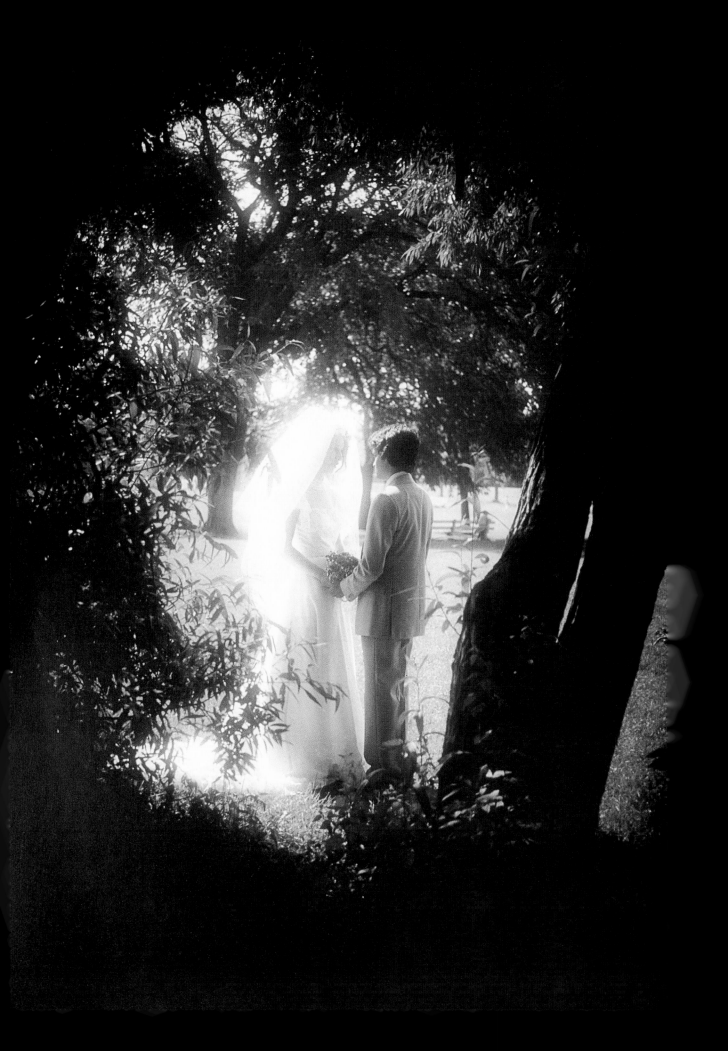

spot from the sun, which shone virtually overhead. The edge of one of those hot spots barely touched the tops of the subjects' heads to create edge lighting.

The light illuminating the couple came from a 40-inch silver reflector which bounced one of the sun's hot spots onto them. The effect created a very bright and tender moment in strong relief against the dark green of the trees behind the subjects. Without the strong reflected light the couple would be in relative shadow from the camera position.

When confronted with a location in which there are lots of hot spots, such as those you can see in this image, we can place our subject(s) in one of the shadowed spots and bounce one of the other hot spots by using a silver reflector.

When working in bright sunlight we might normally consider using either syncro-flash or fill flash, whichever seems most appropriate. But in plate 106, we used a totally different technique, one that you might consider providing you can find a few trees to compose your portrait. In this example the bride was placed with her back to the sun, which immersed her in a totally romantic glow. This would not work very well or possibly not at all if we were not using the vignette created by the trees, because without them the subject would likely have been lost in a background of intense light.

Following my philosophy of matching the light to the subject, in plate 107, I placed the bride indoors where the sun is relatively directional but diffused. This very soft, directional light was totally suited to this tiny, delicately framed woman.

The creative factor here is to ascertain the right position within the room to get the modeling best suited for this subject. In this type of light metering, the light at different points within the room is critical. The ideal exposure for this style of portrait lighting would be f/5.6. Close to the window the exposure may well be between f/8 and f/9.5, but at this exposure the light will be too hot and we will lose the delicacy we have captured in this portrait. By the same token, if she was placed farther from the window and the exposure was f/4 or even more wide open, then the modeling would be softer and the delightfully chiseled lighting pattern would be lost. Of course, with practice and experience you would be able to recognize the best position without metering. See diagram 22.

Taking advantage of large windows when working with relatively weak daylight conditions can provide us with some very different lighting with which to photograph the bride and groom. These situations provide very flat lighting that makes most portraiture very difficult even at a very high ISO. But such situations provide other opportunities, as is shown in the next two images.

In plate 108, the bride was posed laying on the couch in a very comfortable position so that she was outlined against the flat light coming through

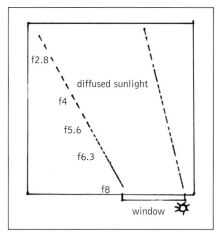

plate 107 (facing page)
diagram 22 (above)

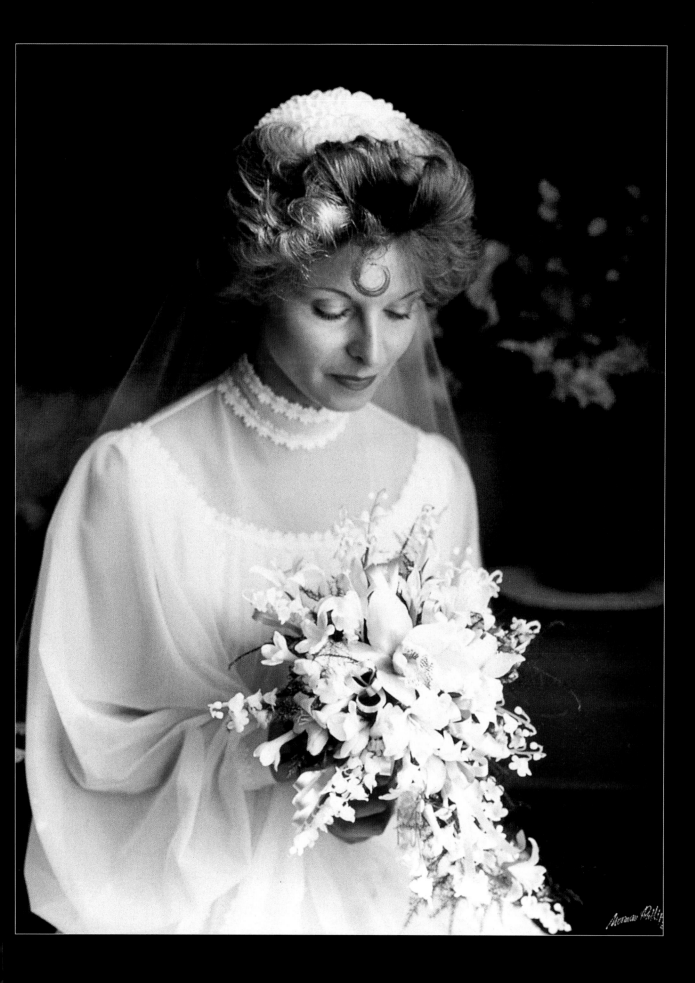

the window. Her groom was placed so that he was in the same plane from the camera as his bride, and he too is outlined against the window light. The light gently sculpted their profiles without them merging into the light from the window. This was possible because the green tints from the trees in the background allowed the light on their faces to have a slightly contrasting background. This was effective because the dark couch and the deep wood paneling in the room created a semi-silhouette as there was no reflected light from anywhere in the room.

In plate 109, we used a similar lighting situation with a different concept—one of romance. The lighting used in this scene worked because in this case there was white upholstery on the window bench to reflect the relatively weak light up onto both the bride and the groom, and there was

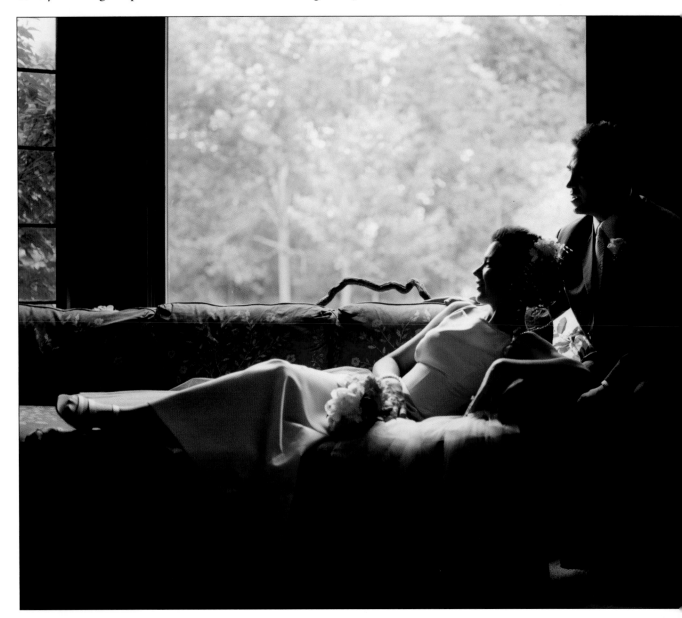

plate 108

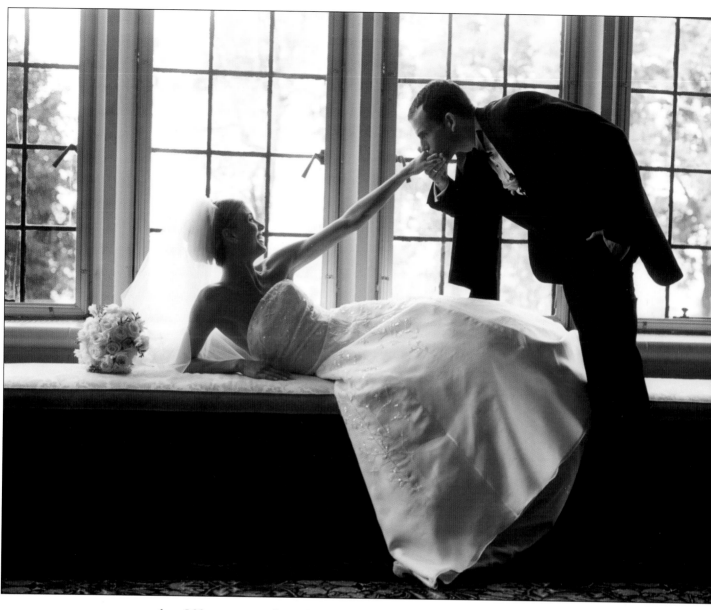

plate 109 some reflected light from her gown. The way the light models the bride's face and arms created a very delicate rendering of skin tones despite the relative weakness of the light.

Producing successful portraits is sometimes a matter of taking advantage of an opportunity to create something different by being aware of how light can work for us.

15. Observation and Creativity

Predominantly, photographers rely on established lighting techniques from which to develop their style and create their lighting sets. Largely these sets are expansions or nuanced innovations based on recognized lighting setups demonstrated by leading photographers such as

plate 110

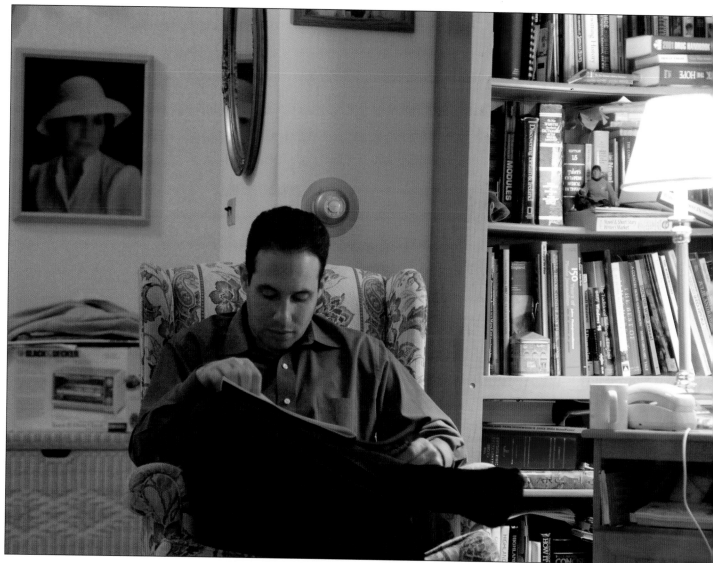

plate 111 Monte Zucker, Don Blair, Claude Gagnon, and Patsy Hodge, as well as many others. But recognizing the effect of light in everyday situations can lead us to creative opportunities that may go beyond what we have covered in previous chapters.

I encourage you to take notice of how light affects everything we see. Commit what you see to memory, and then imagine how you might re-create the same effect, enhance, or dramatically alter the image without compromising or losing the essence of the image.

In plate 110, we have a simple room shot that shows the effect of the three lights in the room, and we will consider how they affect the young man at the bottom right. First, there is one light behind the camera, which provides a weak, flat light. A second light, positioned above the subject and at our left, produced a slight but noticeable light pattern to the top of his head. But the third source, light from the lamp at the bottom right of the image, created a distinctive light pattern. The room lights created an ambient lighting set that allowed for the creation of this image. The image

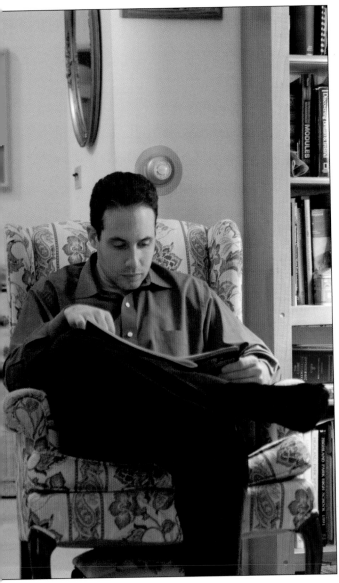

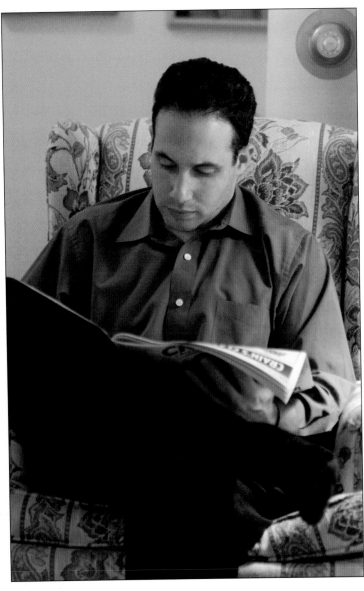

plate 112

plate 113

shown in plate 111 was made in the same light; but in this image, you can see the position of the lamp at the right of the frame. In plate 112, we simply zeroed in and produced an image in which the subject was turned slightly away from the lamp. In plate 113, the subject is shown in a frontal pose to the camera, and this produced a more dramatic impression. The lighting pattern in this portrait exhibits a lighting nuance that falls outside of what is traditionally expected. But if we were to re-create this pattern in the studio with professional lighting equipment, we would have a portrait that is creatively different from the norm. This is an example of how our observations can drive our creativity.

Plate 114 shows the effect of a single lamp positioned some 5 feet to the right of the camera and parallel with the subject, as well as the very low reflected light from the walls in the room. At this distance from the sub-

ject, the lamp produced a soft light quality, and the ambient room light was flat. This same lighting could be duplicated in the camera room with a double-scrimmed softbox or an F. J. Westcott Spiderlite as the key light, supplemented by bouncing a soft light off a reflector at the left side of the camera with a power approximately 2 f-stops less than the key light.

In previous chapters we have discussed flat light and how it may be exploited to produce images that are beautiful to see. The close-up image of a child presented in plate 115 (next page) was captured in a restaurant where all the light was above head height. The overall lighting pattern produced a delightful rendition of a beautiful child. You can tell that the light came from above by the gentle shadow below the girl's chin. The room lighting in the restaurant was, as we expect, on the walls, and one or two were on the ceiling. Because the incandescent lights were all around and produced soft—or as many would say, flat—light, there is a gentle caressing of her features. We could readily re-create this lighting in the camera room with bounced light and reflectors. The difference would be that we would exercise a little more control.

This particular image could be enhanced via different media to produce several exciting images. Observing this lighting in the restaurant I could

plate 114

plate 115

not resist making the exposure. It now inspires me to re-create this style of portrait in the camera room. Again, observation leads to creativity.

Plate 116 shows an image that we may frequently see and take for granted or give little or no thought to except perhaps to wonder why there are so many shoes in the hallway. But when we change our angle of view as in plate 117 and plate 118, we are able to see how dramatic the lighting pattern is and how it shapes each shoe, rim lighting the top and the back of the shoe. These images teach us much about light and the way it shapes not just objects like shoes but how it also renders the faces and figures of our human subjects.

We are able to see how dramatic the lighting pattern is and how it shapes each shoe. . . .

plate 117

plate 118

plate 116

plate 119 (facing page)
plate 120 (above)

We learn so much about the effect of light by observing everyday scenes. Plate 119 presents a simple view of a bedroom window set. Even though the light is the result of a very drab, overcast day, we are able to see it has clear direction, even if somewhat subtle. It is directed from our left. Plate 120 presents a change in the angle of view, and you can see that we would be able to create a very nice lighting pattern with a subject positioned at the right of the window.

Plate 121 is another scene that we might disregard, deeming it as having no significance. It is simply a child's Christmas gift recently unwrapped. But before we cast it aside let's zero in on the Santa Claus at the right and see how beautifully the window light at the right renders its shape as shown in plate 122. Again we are able to see how the reflected light in the room

adds fill as a modified power light might in the camera room. The light-colored cover and paper on the table act as a fill light.

In plate 123, I changed my angle of view by moving to my left and cropped more tightly to bring the subject into a more traditional portrait composition. This produced a more interesting lighting pattern where the light from the window at our left created a delightful rim light all the way down from the top right and also on the shoulder to our left. The same effect could be achieved using a large softbox or perhaps an F. J. Westcott Octabank positioned as indicated in diagram 23.

In diagram 23, a large reflector panel is employed as a fill to virtually copy the lighting pattern in the image. Note that the key light is positioned so that almost $\frac{2}{3}$ of the light is behind the plane of the subject to obtain the rim light shown in the image. The reflector to our left is positioned evenly from front to back of the subject to ensure adequate light to reduce the ratio between highlight and shadow in the front of the subject. The key light is tall enough to match that of the original window light.

Plate 124 shows the subject who appeared in plate 115. This time the light is extremely soft, or as some will say, flat. But the light beautifully caressed the contours of the child's face, while a light from her right acted as a kicker, producing a gentle highlight to the far side of her face as she was presented semi-profile to the camera. The skin tones are almost too delicate to touch and represent the ultimate image of childlike innocence.

There are two ways in which we may re-create this lighting, as shown in diagrams 24 and 25.

The primary source of light in diagram 24 is a small softbox placed slightly behind the subject at a 45 degree angle from both the subject and camera. The light from the softbox bounces onto the subject from two reflectors, one in front of and to the right of the subject and one slightly

diagram 23

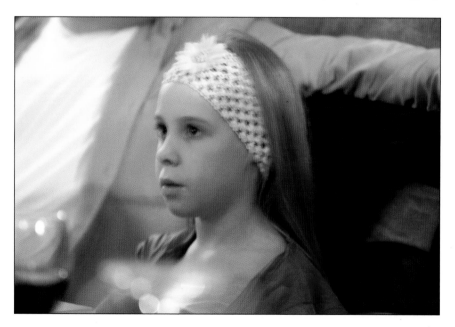

plate 124

diagram 24 (left)
diagram 25 (right)

more to the side. The two reflectors, which serve as the main light, need to be relatively large to ensure very even light across the subject and light the hair. The softbox should be double diffused so as not to be specular.

An alternative setup is shown in diagram 25. To illuminate the face, we positioned two softboxes at camera right at 45-degree angle from both camera and subject, and retained the small softbox employed in diagram 24 at camera left. The bank of two softboxes should be behind the camera position in order to direct a very diffused light. When using this setup, all three softboxes should be double diffused to ensure an overall soft light.

Note that our objectives could also be achieved by placing a reflective trough (a large white curved reflector about 24 inches deep and 6 feet long that produces a wide source of light) or another large white reflector behind the camera position to reflect light from the small softbox to camera left.

In plate 125, another ambient light set inspired a little creativity that resulted in an image that breaks away from the accepted norm. The subject, a man engaged in conversation on his cell phone, was seated at the left-hand edge of a large window and was turned slightly toward the corner of the room behind the camera. The window produced a natural kicker that highlighted the left side of his face and nose and created a depth to his features, while the ambient room light reflected from three walls produced an overall soft lighting effect on the subject. Also his white shirt added a little sparkle to the smile lines around his mouth.

To re-create this style of lighting in the camera room we would have a small softbox positioned as shown in diagram 24 but a little farther back and a little higher. The overall frontal lighting would be produced by bouncing light from a large white panel behind the camera. A silver reflector placed close in and lower than his waist would re-create the light that illuminated his smile lines if he were wearing a color other than white. In our image example, the white shirt reflected light that created the effect.

In plate 126, we simply changed our camera position and created a different lighting pattern that is perhaps even more interesting.

Each of the above observations can be used for creating lighting patterns that differ from those advocated as fundamental requirements for portrai-

The softbox should be double diffused so as not to be specular.

plate 125

plate 126

ture. If we are to be creative, we need to be innovative and finesse standard techniques. When we have learned to see the effect of natural light on our subjects we will easily be able to re-create similar effects in the camera room.

Conclusion

In this book, we have deviated from all the established concepts of lighting that have been advocated for and employed for more than sixty years. What has been demonstrated and described here challenges the conventional while we search for creativity in the use of light. Some of the images will doubtlessly be frowned upon as unsuitable for delivery to our client. But in the search for creativity we are bound to break rules and defy tradition. The notion that our clients will not like some of this creativity is truly false, because one of the reasons why many potential clients do not use professional photographers is that we are not showing this very creativity, and prospective clients do not see images that inspire them to visit our studios.

The concepts discussed in these pages offer all of us the tools to create images that reach beyond traditional portraiture as it has been created and presented for generations. These tips and techniques should be used to expand your horizons and seek new and more exciting ways to portray your clients and seek out those who want something unique and personal that they will be excited to hang on their walls.

Some of the concepts can challenge clients' ideas about wall décor and fine art. But fine art falls into various categories, and the various styles of portraiture discussed here have not been included amongst the choices offered to those who appreciate it.

Much of what was covered in this book can be used as a starting point for even more creative images. There is no limit to the potential that light provides, and all it ultimately requires is for us to learn to both see light and what it can do in the search of something totally different.

Hopefully, the ideas and techniques discussed in this book have inspired you to take a step away from everything you have accepted as the "right" way of creating portraits.

In the search for creativity we are bound to break rules and defy tradition.

Equipment Explained

In this book, reference has been made to a variety of lights and lighting accessories. What follows is a description of the equipment used in the book, as well as items that may not have been mentioned that you will find useful in your quest to produce innovative images.

When you have decided on a particular lighting setup, you will find there is an accessory that is well suited to it, provided you have familiarized yourself with the effect of light, whether it be studio, natural, or a combination of both.

● THE EQUIPMENT

Blockers. These light modifiers (also called subtractive screens or gobos, because they go between the light and the subject) are used to block light from falling on different areas of a subject and to direct a narrow light source onto the subject. Blockers can be purchased from photographic supply companies or homemade. In this book we used a 4x8-foot sheet of Gatorfoam, cut it into 16-inch panels, and hinged them together concertina style. One side was painted black and was used to block light. (The other side was painted white and used to reflect light over the full length of the subject.) Gatorfoam is lightweight but sturdy and is available in most do-it-yourself stores.

Bowens MystiLite. This softbox has an 18 percent gray interior. When used with a second diffusion panel, the light produced is ultra soft and can be used within inches of the subject, producing beautiful skin tones. Other softboxes can be modified to create a similar effect by attaching gray panels on all four sides of the interior.

Grids. Grids (also known as honeycombs) can be attached to strobes or softboxes for enhanced lighting control. They are often supplied as part of a softbox kit or sold separately. Fitting a light with a grid forces the light

> When you have decided on a particular lighting setup, you will find there is an accessory that is well suited to it.

to travel in a straight line, and thus provides excellent light control, enabling us to illuminate specific areas of a subject.

Halo Mono Light. This modifier, manufactured by F. J. Westcott, is an umbrella with a reversed umbrella made of diffusing material at the front. This product produces a softer light than would a single white or silver umbrella. In our studio, we feather its light across the subject and also allow its light to bounce off an adjacent wall, providing fill for added sparkle.

Octabank. The Octabank, an octagonal softbox manufactured by F. J. Westcott, is available in 5 and 7-foot circular configurations, making it the largest portable softbox available (it weighs only 5lbs!). It produces a very large field of light that mimics the light produced by a large window.

Pan Reflectors. A pan reflector is a parabolic pan-shaped modifier and in most cases has a central deflector to diffuse the light around the pan. This modifier produces a very flat but bright light that is most appropriate when producing glamour portraits with the light close to the subject at the same position as the camera. Some pan reflectors have attachments that provide a form of vignette as its coverage falls off at the edges and, when used accurately, creates a controlled portrait lighting tool. However, it is not the same as a conventional vignette.

Reflectors. Reflectors are accessories that are used to bounce light. The reflective surfaces are commonly available in silver, gold, and white. A silver reflector produces a specular effect, a white reflector produces a softer light, and a gold reflector is used to produce a warm light quality. There are other colors available that can be used to fill a particular need for any given assignment. Photographers can also choose from a variety of surfaces, from highly reflective to matte, depending on their needs. Some reflectors are transparent. These filter light and are used to reduce the specularity of light or to reduce its intensity (for instance, to soften the effect of sunlight when working outdoors).

Reflectors come in a variety of sizes and shapes. Very large sizes (say, reflectors measuring 10 feet) are suitable for coverage of a large subject or area. More portable reflectors are commonly taken on location for assignments such as outdoor portraits. Some reflectors can be employed with the flick of the wrist and folded away with the same action, then stored in a special carrying case. These latter reflectors are available in sets of three.

Snoot. A snoot is a tubular accessory that is used to create a narrow, nonfocusable spotlight effect. Snoots are available in 8 to 12 inch lengths (depending on the make). The light produced with a snoot is contrasty in nature. It is sometimes used as a hair light or to create a spot of light on the background.

Softboxes. A softbox is a box-shaped modifier that directs diffused light through a front panel, producing a bigger, softer light effect. Many softboxes provide a second, removable layer of diffusion material. This double

Reflectors are used to bounce light. The reflective surfaces are commonly available in silver, gold, and white.

diffusion produces a much softer light than single diffusion. Softboxes are available in a wide range of sizes and configurations and from various manufacturers and suppliers.

Softboxes are manufactured with a variety of internal surfaces, including white (which produces a soft light), silver (which produces a harsher light), and 18 percent gray (which produces the softest light).

Many softboxes have a recessed front panel diffuser, which allows for more control over the direction of the light. Additionally, some manufacturers, such as F. J. Westcott, provide kits with the purchase of a softbox that includes accessories that attach to the front of the box and narrow the source of the light, providing greater control. *See also* Octabank.

SpiderLite. This unique lighting tool, manufactured by F. J. Westcott, employs five incandescent or fluorescent tubes housed in a softbox. The fluorescent tubes are balanced so as to make available a daylight effect that is portable for studio or on location.

Stripbank. A stripbank is a narrow softbox that will extend in length up to 72 inches. These boxes are mostly about not deeper than 10 inches and are often employed as hair lights. They are the most appropriate when a narrow strip of light is required. Its narrow coverage offers greater control than a larger size softbox. Egg-crate accessories are available for more precise control.

Master's Brush. This is a proprietary lighting product produced exclusively by F. J. Westcott. It has a built-in vignetter that allows precise control in directing the light and eliminates the need to vignette in the camera or post-capture.

Umbrellas. Umbrellas may well be the most popular type of light modifier available, and they come in numerous sizes and configurations. Because umbrella light is projected over an area significantly larger than its own width, a very wide source of light is produced, which, in comparison to the light output by a softbox, is more difficult to control. Of course, the spread of light umbrellas produce can be very useful, and the size you select should be based on the area you wish to cover.

Umbrellas have the same surface options as softboxes, including silver, silver/white, gold, and white. Diffusers are also available for some umbrella types.

Two unique umbrellas are the Halo and Halo Mono, produced by F. J. Westcott. These umbrellas have a reverse umbrella in front of the base umbrella construction that provides a wide coverage of soft light. The Halo Mono's construction allows you to access the controls on the rear of your mono light. These models are available in several sizes.

Note: All the F. J. Westcott equipment/accessories described above are available at www.normanphillipsseminars.com or by calling 800-792-2092.

Softboxes are available in a wide range of sizes and configurations from various manufacturers.

Index